State Fair

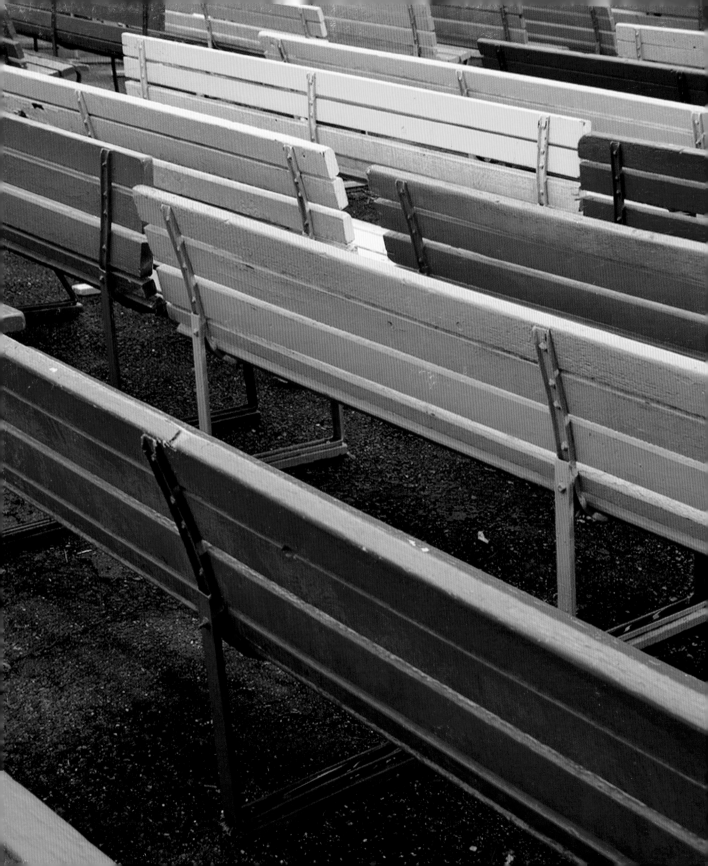

State Fair

The Great Minnesota Get-Together

Photographs by Susan Lambert Miller
Foreword by Lorna Landvik

 MINNESOTA HISTORICAL SOCIETY PRESS

www.mhspress.org

The Minnesota Historical Society Press is a member of the Association of American University Presses.

Manufactured in China

10 9 8 7 6 5 4 3 2 1

∞ The paper used in this publication meets the minimum requirements of the American National Standard for Information Sciences—Permanence for Printed Library Materials, ANSI Z39.48-1984.

International Standard Book Number
ISBN 13: 978-0-87351-615-0 (cloth)
ISBN 10: 0-87351-615-X (cloth)

Library of Congress Cataloging-in-Publication Data

Miller, Susan Lambert, 1948–
 State fair : the great Minnesota get-together / photographs by Susan Lambert Miller ; foreword by Lorna Landvik.
 p. cm.
 ISBN-13: 978-0-87351-615-0 (cloth : alk. paper)
 ISBN-10: 0-87351-615-X (cloth : alk. paper)
 1. Minnesota State Fair—Pictorial works. 2. Minnesota State Fair—History. I. Title.
S555.M666M55 2008
630.74'77658—dc22
 2008000033

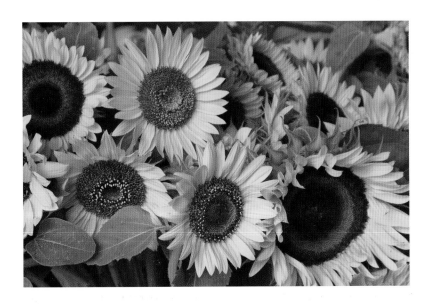

For Stephan Courtright, hairstylist and fair muse extraordinaire

Butter Princess

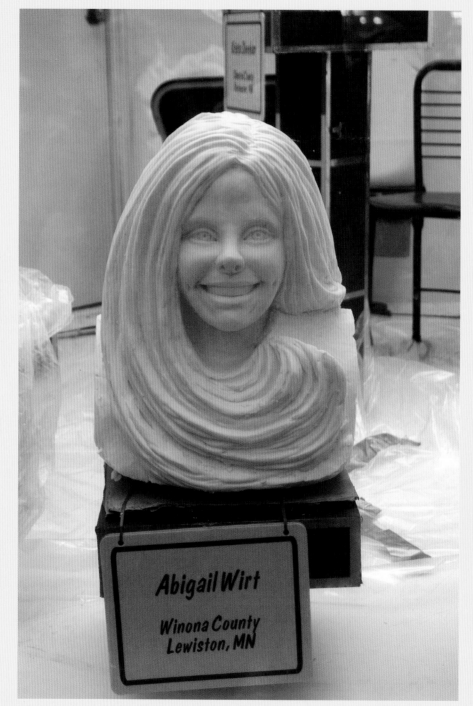

Abigail Wirt

Winona County
Lewiston, MN

The Fair Maiden

As told to Lorna Landvik

As the *Fair Maiden*, unofficial historian of the State Fair, I recently opened a snappy maroon and gold booth (west of the Swine Barn, south of Forage) to collect stories and anecdotes of fairgoers. High up on my own long, long list of why I love the fair is this: It brings out the passion of a people who aren't always eager to demonstrate it. Were it a punctuation mark, the fair would be an exclamation point. Were it a color: barn red. A song: well, it certainly wouldn't be "Our State Fair," because the lyrics make the claim that *their* state fair is the best state fair in *their* state. And everyone who knows state fairs knows that *ours* is the best…in the known universe. But don't let me, a PhD candidate in Minnesota Lore (I'm nearly finished with my thesis: *Jesse Ventura—Was It Something in the Water?*), explain the reasons why. Here's what the people say.

The wife says I'm not the most romantic man in the world, but then she says if she'd wanted romance, she wouldn't have married a soy farmer. I'd say Florence is not the most beautiful woman in the world, but then if I'd wanted beauty, I would have married her cousin Louise. Yeah, and if you think I'd ever say that out loud, you haven't seen the size of my wife.

We've always celebrated our wedding anniversary at the state fair, and because this year was our forty-fifth, I wanted to treat her to more than the usual three pronto pups and refills on the Swedish egg coffee. By golly, this was an occasion I wanted to show her some romance. And I'm here to tell you that sometimes the planets are in alignment and the universe hears a soy farmer's secret desires, because ladies and gentlemen, there is now a wine tasting bar in the Ag-Hort building.

"A delicate red for the lady, with hints of pear and blackberry," I said to the man behind the counter, and the thud I heard was not the nine-hundred-pound pumpkin falling off the loading dock.

"Florence, honeybunch," I said, helping her to her feet. "Are you all right?"

"I'm…fine," she said, palming her permanent. "It's just…well, I was expecting maybe a Ye Old Mill ride or a tour through the motor homes…but not this."

After sampling some crisp whites, some mellow reds, and some yearning rosés, we meandered through the building. Year after year, we'd admired the vegetable displays, but never before had we been so struck by the gloss of the red peppers, the sheen of the eggplants, and the shapeliness of the summer squash. Studying the potato entries, I couldn't help myself; I leaned over and whispered some of the more exotic names into the wife's ear.

"Kennebec…Red Pontiac."

"Oh, more," said Florence, a flush darkening her rosacea.

"Irish Cobbler," I said, clasping her elbow as she swooned.

We paid homage to the late, great Lillian Colton and those artists who've followed in her stead, making still lifes of Spam cans and wagon wheels as well as portraits of Dick Cheney and Wayne Newton out of flax and red millet and sesame seeds.

By the corn, we eavesdropped on a father explaining the facts of life to his son.

"See the tassel up here at the top?" he said, pointing to a cob. "That's the male part. And this silk here? That's the female part. Each strand of silk has to be pollinated by a tassel to make a kernel of corn."

Florence wondered if it was hot in the building or if it was just her.

"It's just you," I said, and then I did something I never did at the fair or anywhere else: I drew the wife toward me and then, tipping her back in a regular old tango hold, I kissed her. Long and hard, and when I came up for air, the corn tassels trembled in my exhale.

BOB, 67, POLK COUNTY

The police were nice enough, I guess. Nothing will go on my record, after all. The real shame would have been if my grandmother (twenty-one blue ribbons!), my mother (seventeen blue ribbons!) or my Uncle Hy (eleven of 'em!) knew of my disgrace. Kings and Queens of the Creative Activities Building, they've long since entered that great fairground in the sky, where everyone's entries, I suppose, are blue winners. I just wanted to get one while I was here on Earth.

I come from a family of competitors. We kids were all in 4-H and showed our projects at the fair. From sixth grade to twelfth, I entered my hand-sewn outfits, and—no bragging—my Dr. Spock–inspired snowmobile suit was a shoo-in for the blue, on originality alone. That was

the year my sister Darlene sang in the *Oliver!* revue and my brother Ned exhibited "A Tale of Soil Erosion," in 3-D no less. Both took home blue ribbons. Mine was pink.

My grandmother's festive potato salad, festive gingerbread, and festive blonde brownies; Mom's whip-stitched baby blankets and crocheted oven mitts; Uncle Hy's driftwood lamps and birdhouses made of bottle caps—oh, the miserable list goes on and on, and my name's never on it. Can you see where decades of disappointment would lead me to this?

This year's quilts were beautiful, as usual, and the blue ribbon pinned to the winner was just so…accessible. I couldn't help removing it, with plans to claim it as my own. (How could my apron, appliquéd with a picture of George Clooney and a speech bubble reading, "My Hot Mama" not even place?!) Well, I had more trouble liberating that ribbon than I thought, and the quilt racks were clanging together, and people started whispering, and pretty soon Security had me by the elbow.

I apologized. I cried. I carried on—and they believed me. In fact, I truly think that if there were a blue ribbon for improvisational acting, it would go to "the lady who claimed an obsessive-compulsive disorder compelled her to re-pin the ribbon at right angles to the stitching line."

PENNY, 56, WADENA COUNTY

Yesterday I become citizen, and today I am here to the State Fair to practice being not only American but Minnesota American. For long time, I sit on bench, watching great parade of fellow citizens walk by. Some wear paper pickle hats and carry yardsticks (what they are measuring, I do not know). Blonde-headed people more than I have seen anywhere. Girls and boys with hands are buried in each other's backside pockets. A man with shaved head, eyes lined, and tattoos climbing over arms and legs like weeds. Many, many, many, many had food in hand and mouth. Paper sacks of saltwater taffy (this is true—the sea makes candy?). Sno-cones looking like iced rainbows! Sugared donuts the size for babies! And so many things that taste good all by themselves yet are coated with batter and put in the hot oil to fry deeply. Cheese! Hotdogs! Tomatoes! Onions! Fruit! Even candy bars, which already are too much in flavor! I like, however, these many things on a stick, saving need for plates or forks—yes, I big admirer of great American efficiency!

Passing me suddenly was big noise—drums and trumpets and flutes and the big shiny instruments with long sliding tubes. So excited, I stand and clap, the music so beautiful, the young players' faces shiny with sweat and from wearing hats with fur and clothes with many buttons. Pretty girls twirling sticks into the air. Marching music makers, playing loud and fast, the bass drums: *Boom! Boom! Boom!*

Smiling, I think: this for me. This my welcome as new American citizen. I very happy, and because I now Minnesotan, eat for first time hotdish. Of course on a stick.

MELANDA, 38, FORMERLY OF MALI, AFRICA, NOW ANOKA COUNTY

I almost made it to the talent show finals this year. Teen division. I have a comedy act. Which is a lot harder than putting on a sparkly silver leotard and doing the splits, if you ask me. Okay, maybe not the splits.

I wrote the routine myself—about an alien landing at the State Fair.

"Take me to your leader," I say in a robot voice, "but first let's stop at Sweet Martha's."

"Your Skyride transport is underwhelming," I say in the same voice. "Ours travels the speed of light."

My brother told me to cheer up; someday people will understand my sense of humor. He said sometimes it takes a while for people to appreciate originality. Then he tried to get the phone number of the girl in the sparkly silver leotard.

JOSHUA, 13, FILLMORE COUNTY

I always take the van to the fair. I need the room. I'm a compulsive shopper, and the fairground is my emporium.

It started when my last son went off to college. I'd gone to the fair with my girlfriend Midge, and we took a seat in the Grandstand to watch a guy turning regular vegetables into art with a special knife. Well, I just had to have a set, although I can't tell you the last time I made rosebuds out of radishes.

That same day, Midge and I were entertained—really, those guys are showmen!—by a fellow whipping up all sorts of concoctions in a super blender. After we sampled the ice cream he'd made out of broccoli and pistachio pudding mix, there was no way I couldn't get out the credit card. I've tried re-creating that ice cream, but I think I have the ratio of broccoli to pudding wrong.

There are only three destinations for me at the fair: the Merchandise Mart, the Grandstand, and the International Bazaar. I refuel as I dash between them—a turkey leg or gyro for stamina, a frozen Key lime pie for energy.

A sampling of this year's booty: three jars of flavored garlic guaranteed to add zest and savor to any recipe, two wool hats from Guatemala, hand-smocked doll clothes, cookware that can never burn, a pair of Swedish clogs, a water purifier, a blown-glass vase made by real artisans,

hair extensions, personalized Halloween lawn ornaments, a pound of buffalo jerky, a crystal necklace with healing powers, and a sewing machine with a monogram and embroidery attachment.

The only unpleasant part of an exhilarating day was when we unloaded the van and—surprise, surprise—my husband, Stan, hadn't fallen asleep to the ten o'clock news (broadcast live from the fair!) as he always does. He did not seem overjoyed at my purchases.

I've got to make sure he's out of the house when they deliver the dining-room set and the baby grand.

BARB, 60, CARVER COUNTY

My sister and I were always politically active, so when we went to the fair, you can bet we spent a lot of time at the DFL and GOP booths. Gad, I practically got the wind hugged out of me by Paul Wellstone, and then I had to listen to him talk a mile a minute, excited about everything. He always remembered my name, even though I made him understand I usually voted on the other side.

"Not usually," my sister Alice told him. "Donald's been a Republican since he cashed his first check."

I'd give her plenty of what-for when we visited my candidates.

"Gad," I told her, "you'd never know you're a yellow-dog Democrat the way you were flirting with Dave Durenberger."

"I always appreciate a handsome man," said Alice, "no matter if they dance on the wrong side of the aisle or not."

But we didn't just rib each other; we went to air our beefs and hear what the folks in charge had to say.

"Because you know," Alice liked to remind them, "we're the ones who put you there and we're the ones who can take you out."

Gad, I miss her.

DONALD, 85, PINE COUNTY

It's weird, of all the things to do at the fair, I wound up in the Meditation Tent. I had it all to myself until this guy with a beard and braces came in and sat cross-legged for awhile. Then a big lady with a red face barged in and asked if I was a nurse 'cause she thought she'd been stung by a bee. That's when I noticed the guy with the beard had braces because he opened his mouth to say, "This is a meditation tent, ma'am, not a MASH tent."

It wasn't the funniest joke, but I laughed because I needed to.

I've been a vegetarian for two years—not the easiest thing when your grandparents on both sides raise beef cattle—and I'd just told my dad that morning I'd become a vegan.

"Now what the devil is that?" he asked.

"Someone who doesn't eat anything that comes from an animal. Not meat, not eggs, not cheese, not milk."

Dad had the kind of smile that doesn't indicate a lot of pleasure. More like a sharp pain. See, Dad's a dairy farmer. And this year, I'm a Milky Way princess.

He shook his head. "How'd you come to this…decision?"

"I…I've thought about it a lot, and I…I just want to live lighter on this earth."

My dad dragged his finger under his nose. "If everyone wanted to live lighter on this earth, I'd be out of business. So would your grandparents."

After the Meditation Tent, I wandered around awhile. I watched some old people square dancing and counted the fish swimming around at the DNR. I took a ride down the Giant Slide and had a pineapple sno-cone. Finally, I went to the Judging Arena, knowing my dad would be there.

"Pretty heifer," he said when I sat next to him.

I looked out at the ring and agreed.

"So are you," he said, patting my knee with his clamped hand.

My throat felt thick.

"So what are you going to do about tomorrow?"

"Huh?"

"Tomorrow," said my dad, tugging at the bill of his cap. "You're supposed to sit for your sculpture, right?"

I nodded. It's this weird ritual that all the princesses get to have a sculpture of their face made—in butter.

"If I were you—I mean, if I wanted to live lightly on the earth—well, I'd have it done in margarine. Or peanut butter."

I looked at his face—sometimes it's hard to tell if my dad's joking or not.

"Then again, I doubt even organic peanut butter could capture your beauty the way butter can."

He smiled and put his arm around me, and I smiled back and told him the truth: I was proud to be the daughter of a dairy farmer.

MEGAN, 19, CASS COUNTY

Seventy-nine is not so old when you feel forty. And the way to feel forty is to get off your duff! We go to the fair with my brother Charlie and his wife, but all he wants to do is sit on the John Deere equipment and all June wants to do is sit in front of the 'CCO booth and I can't get my wife away from the Leinie Lodge for love or money. So now I cruise the Midway all by myself. Anything that twirls, whirls, scrambles, shakes, drops, hops, circles, plunges, swoops, or swings—I'm on it. My wife who can't ride a merry-go-round without saying good-bye to whatever she just ate says I've got an iron stomach and a cast-iron skull.

My favorite is the bungee jump. I like to yodel on the way down and then on the way up. I like to think I'm taking a bobsled ride on my own invisible Alps. When I see old guys sitting in the beer gardens or shuffling around Heritage Square, I want to holler, hey bud, take a ride! Lose your breath! Forget about gravity—being upside-down is a great way to look at the world!

ED, 79, BELTRAMI COUNTY

So you see, everyone's got a story, and I hope that the next time you're at Minnesota's Great Get-Together, you'll tell me yours. But until the gates open again, and the smell of cheese curds and cotton candy wafts over Snelling Avenue, sit back and enjoy these photographs. Just think of all the gazillions of stories they represent.

Sunflowers
& Sky Glider

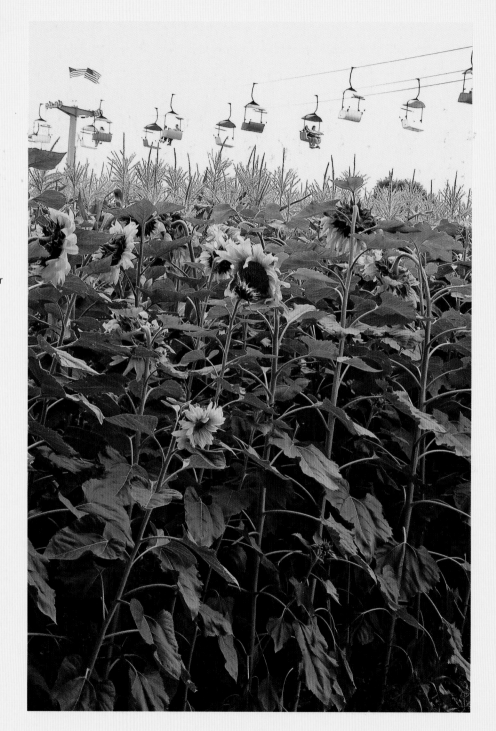

State Fair

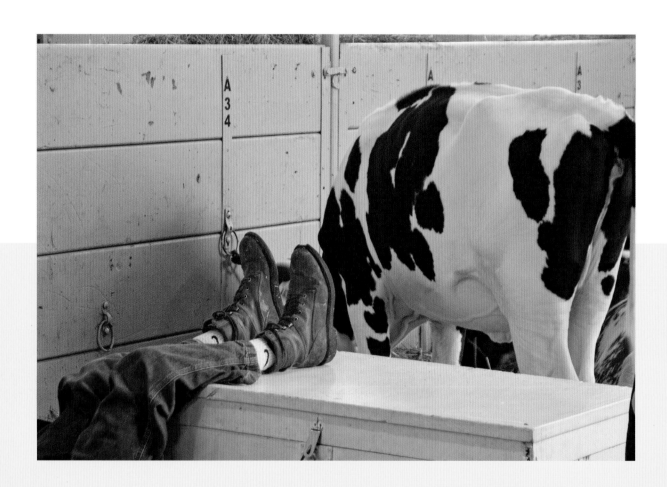

Cow, Boy, Boots

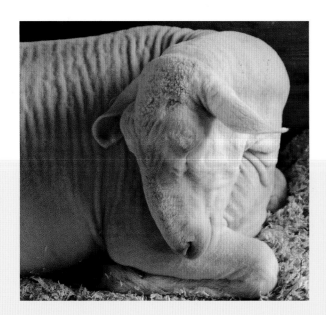 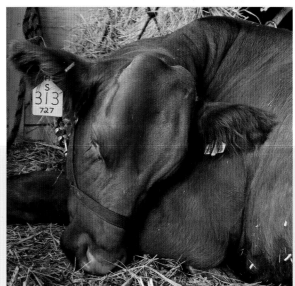

Sheep & Cow in Repose

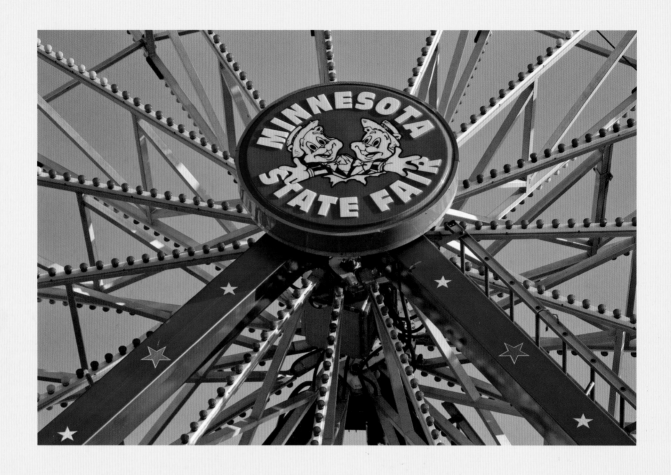

Big Wheel

Pavilion

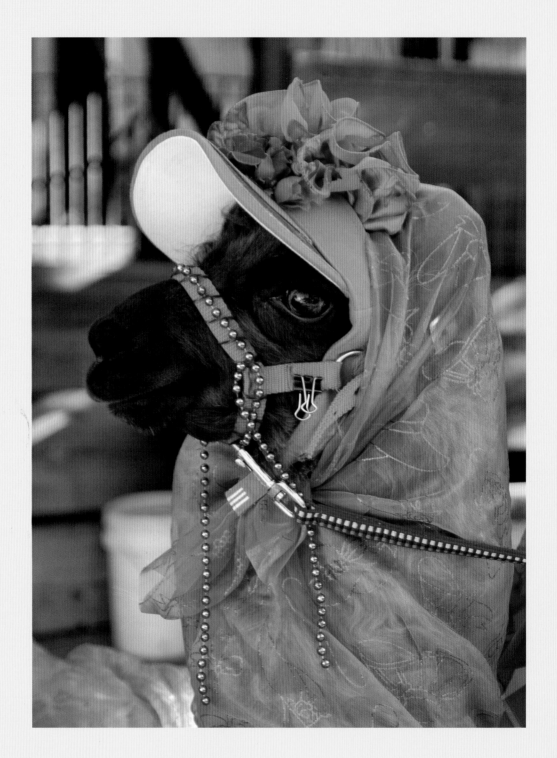

Red Hat Llama

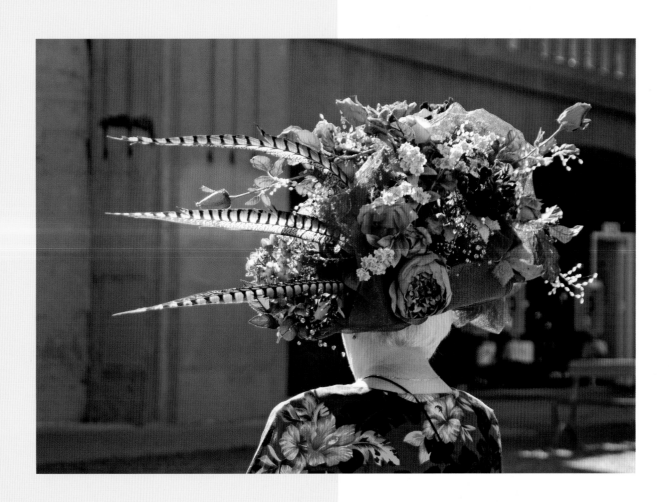

Red Hat Lady

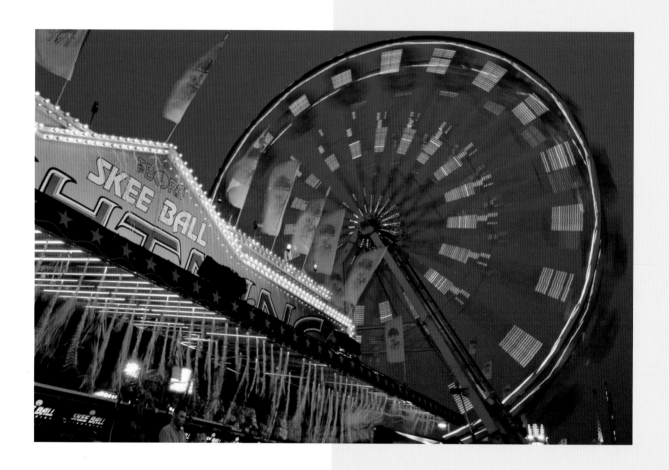

Skee Ball

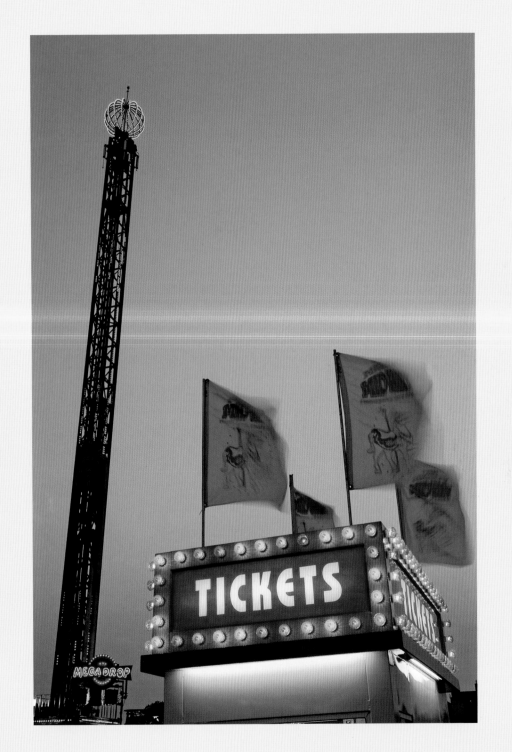

Tickets

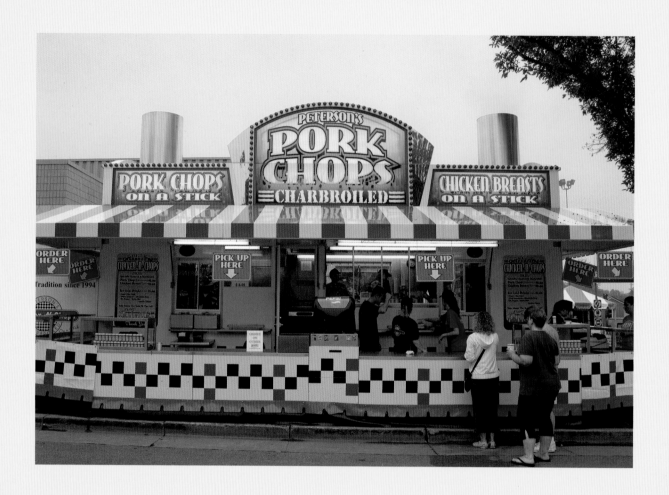

Charbroiled

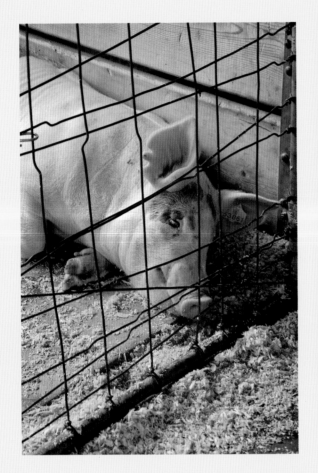
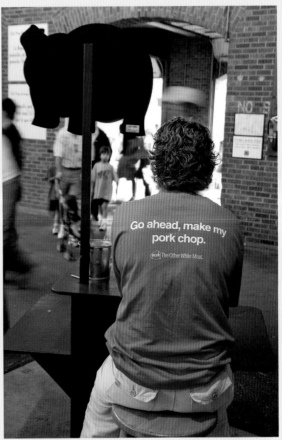

Make My Pork Chop

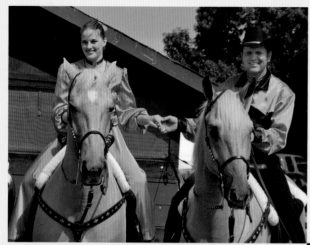

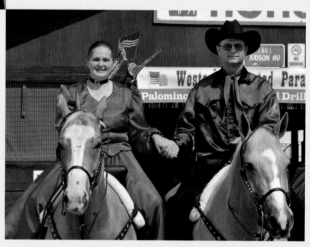

Equine Square Dance

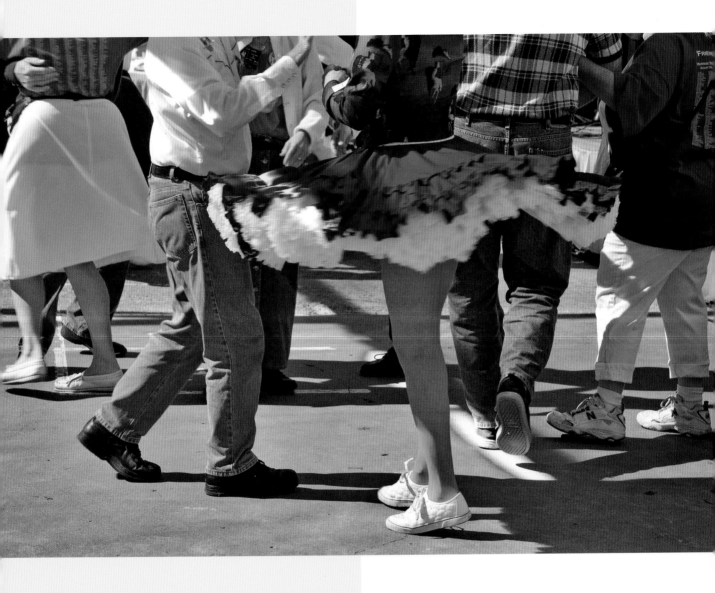

Human Square Dance

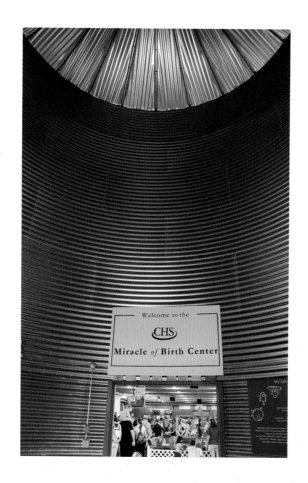

Miracle of Birth Center

Miracle of Birth

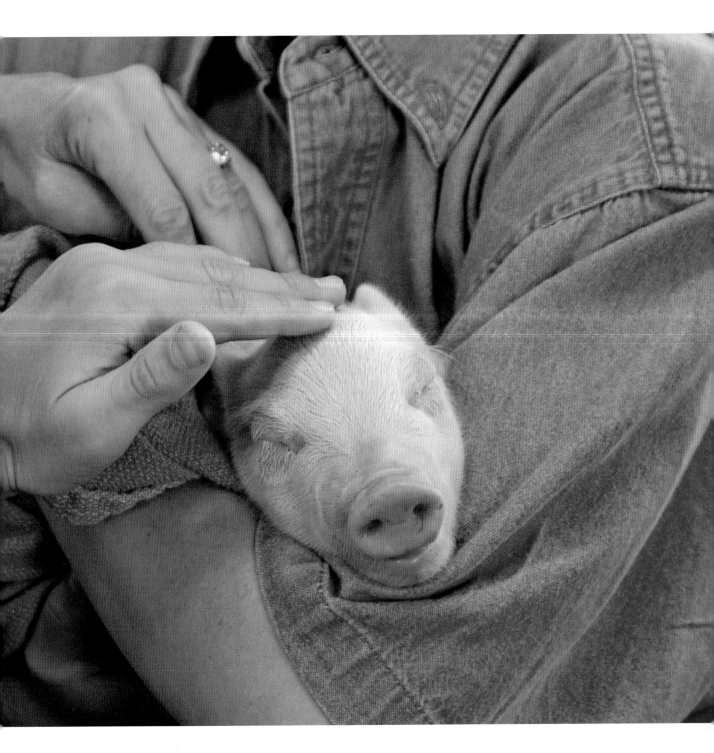

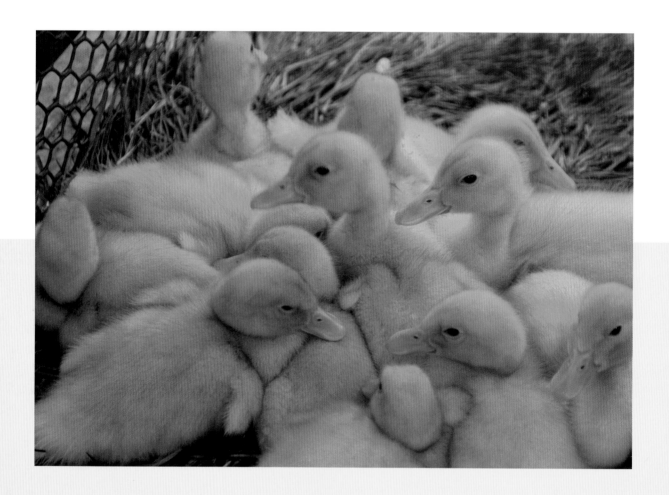

Ducklings

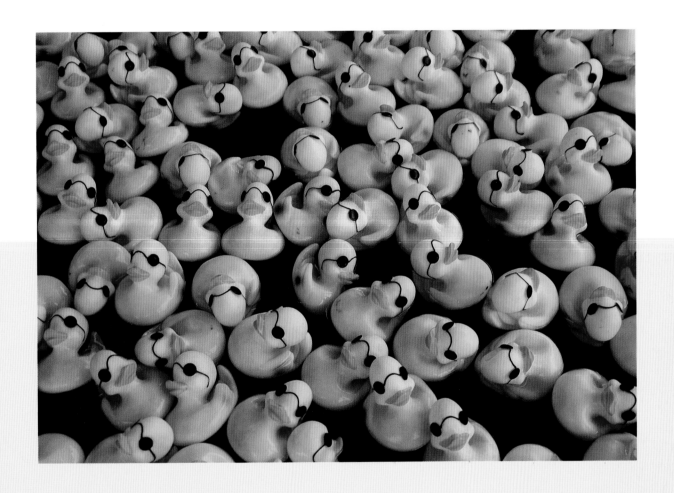

Duck Blind

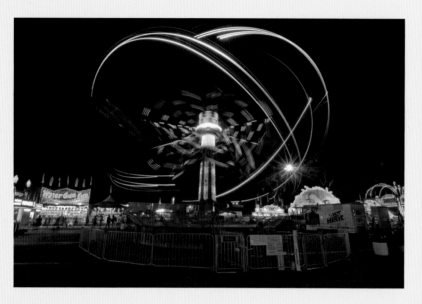

Midway — White Swirls

Midway — Octopus

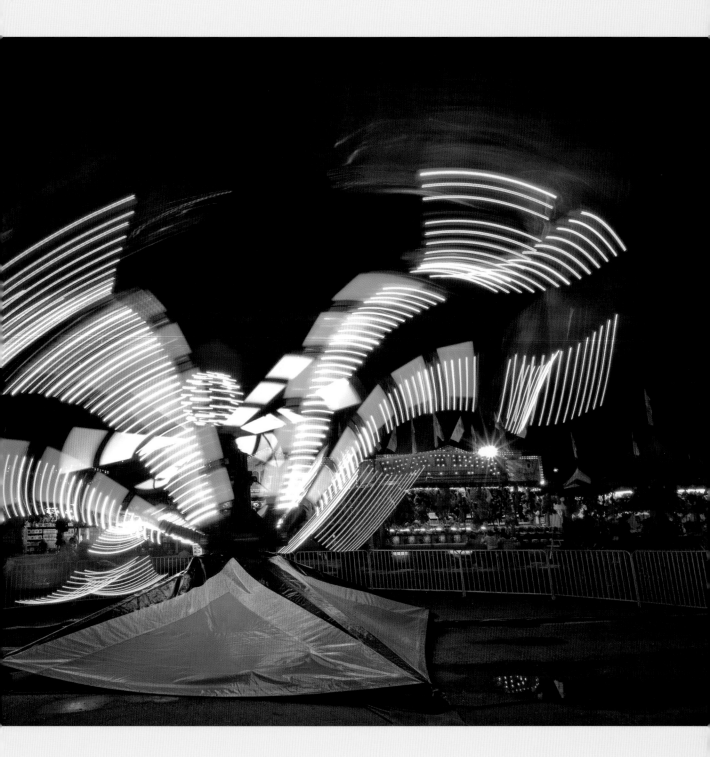

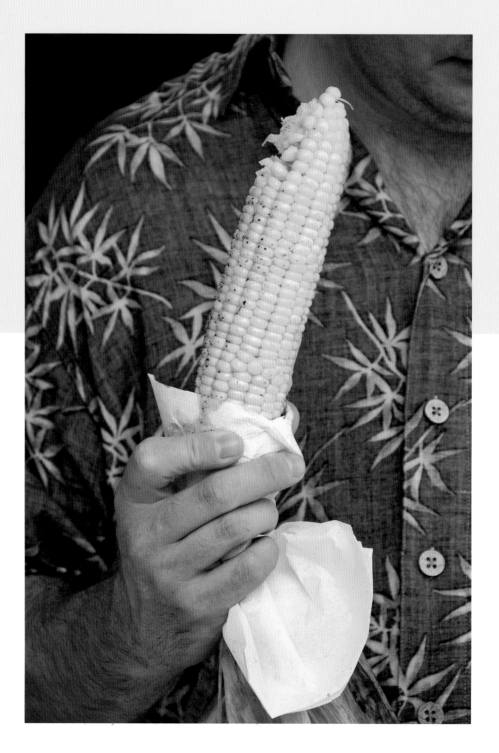

Favorite Fare

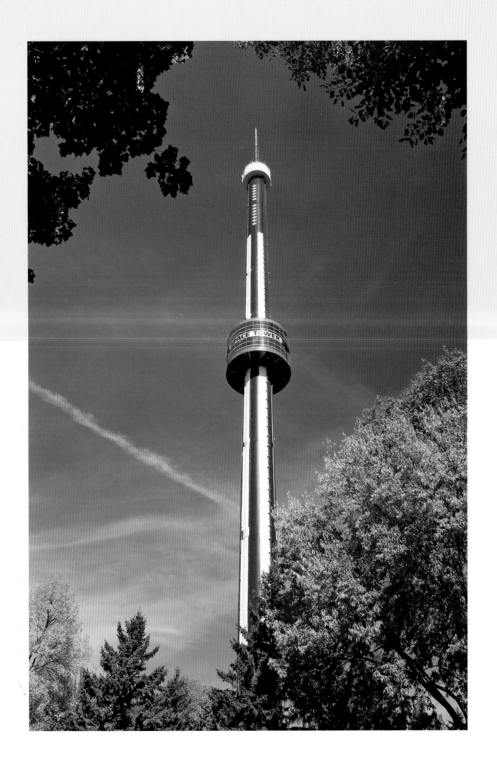

Fair Favorite

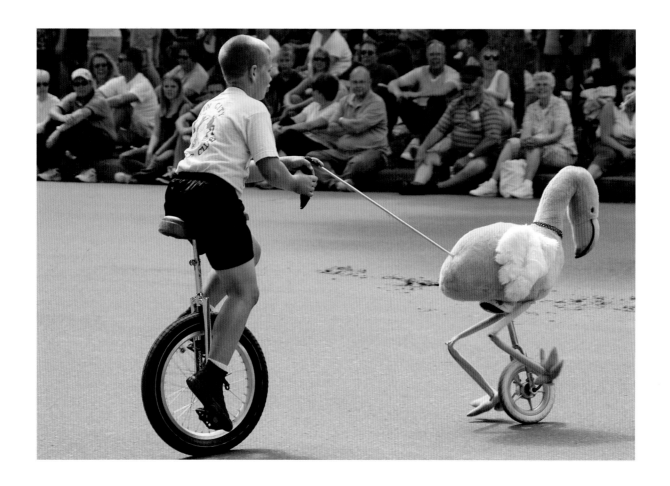

Flamingo Road

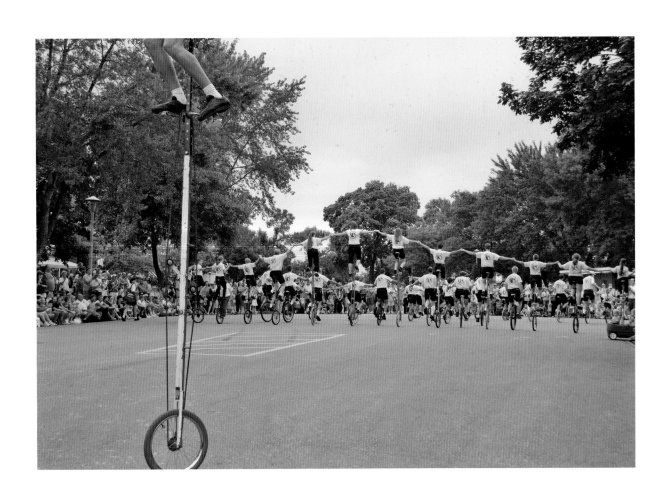

Equilibrium

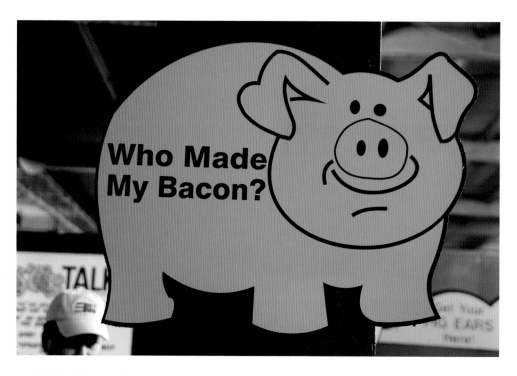

Who Made My Bacon?

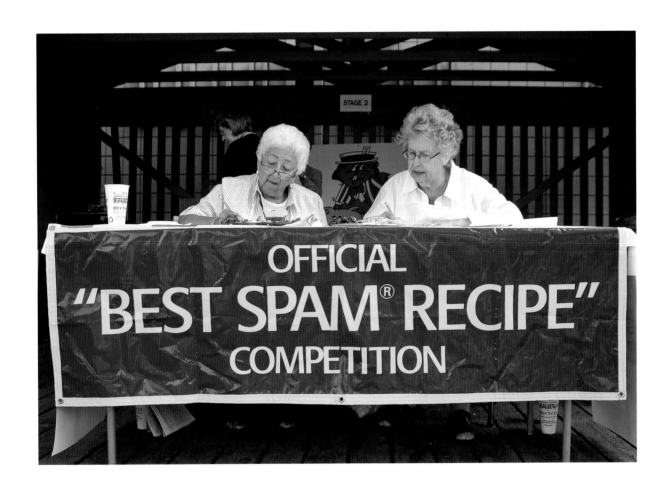

Best Spam

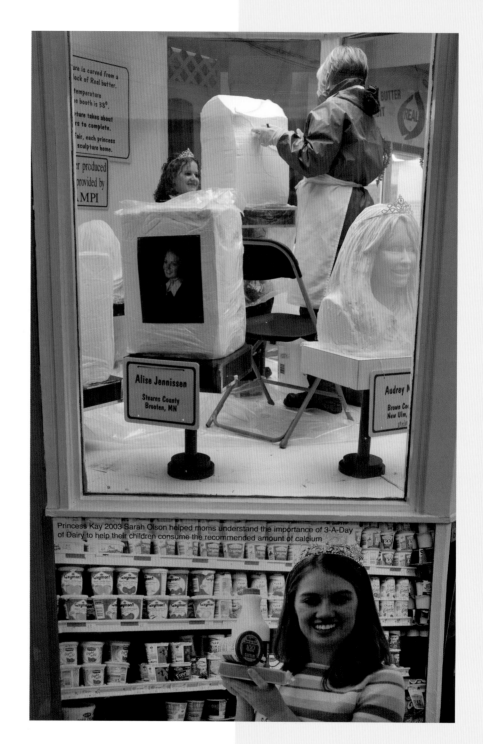

Crowned Butter

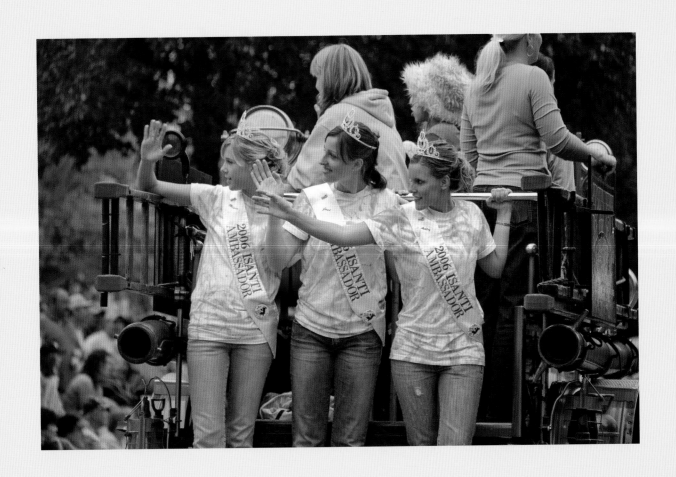

Crowned Heads

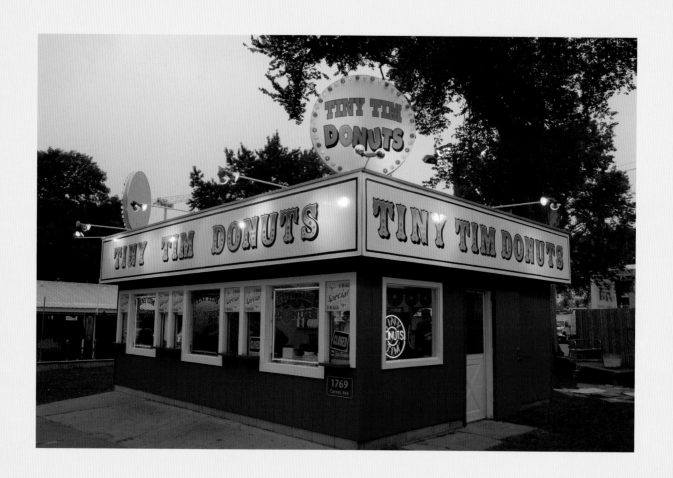

Tiny Tim Donuts

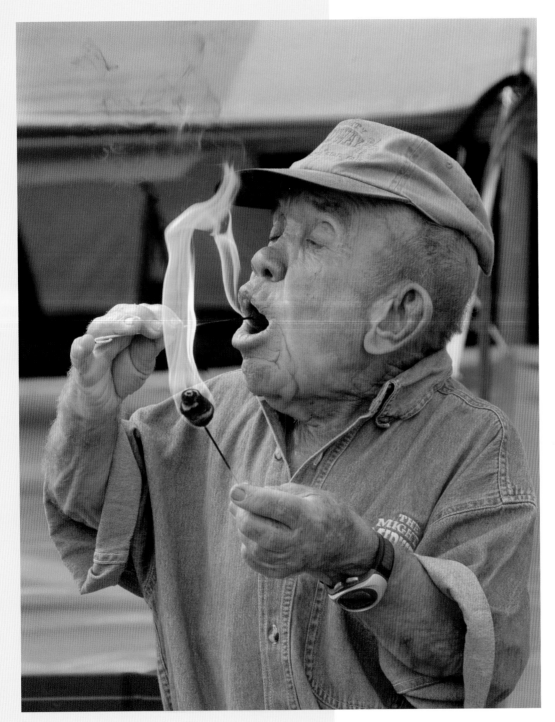

Tiny Fire-eater

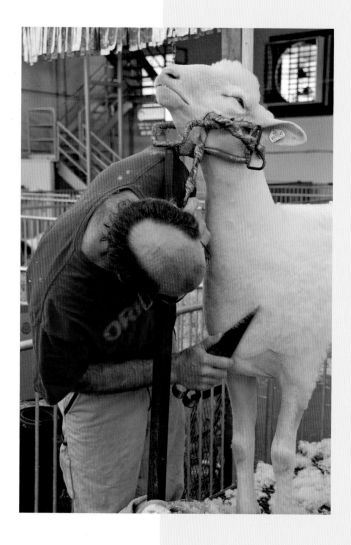

Sheared

Bad Hair Day

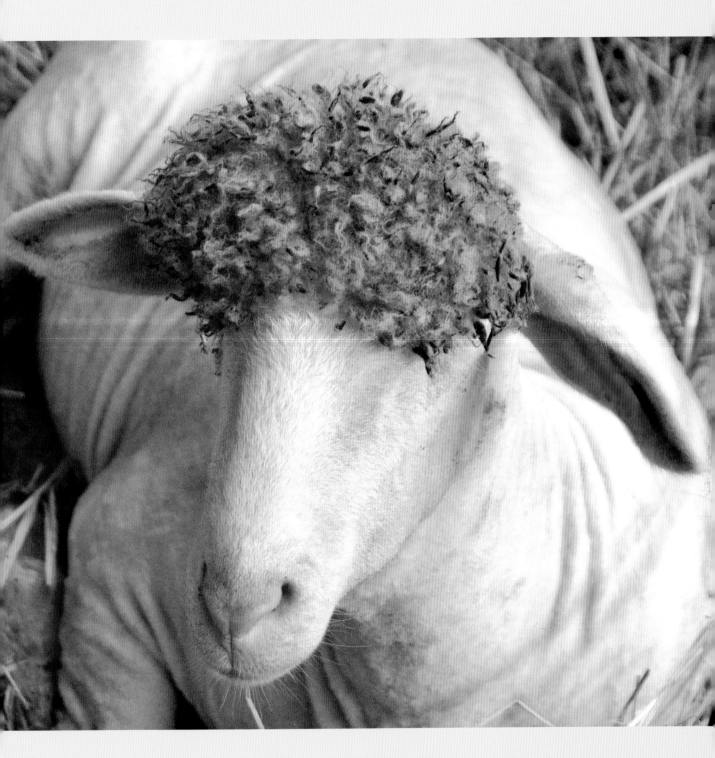

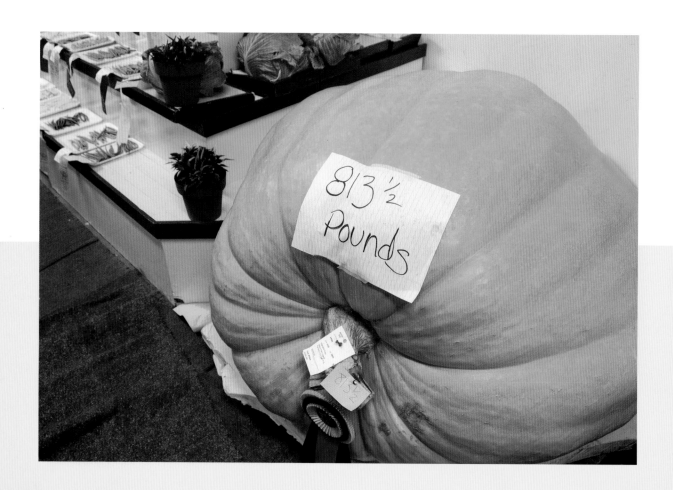

The Great Pumpkin

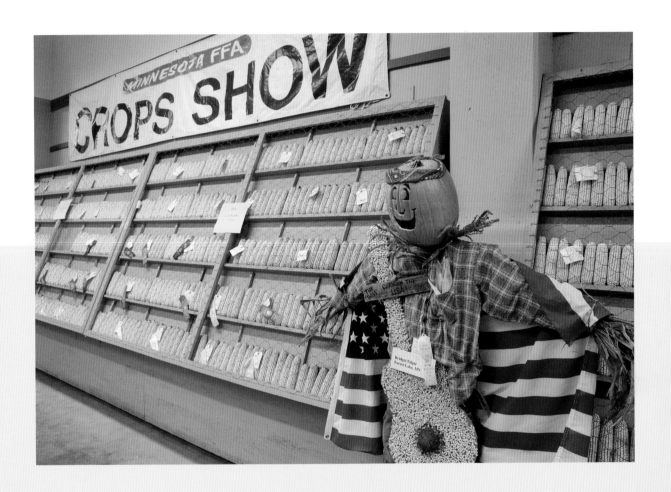

Corn in the USA

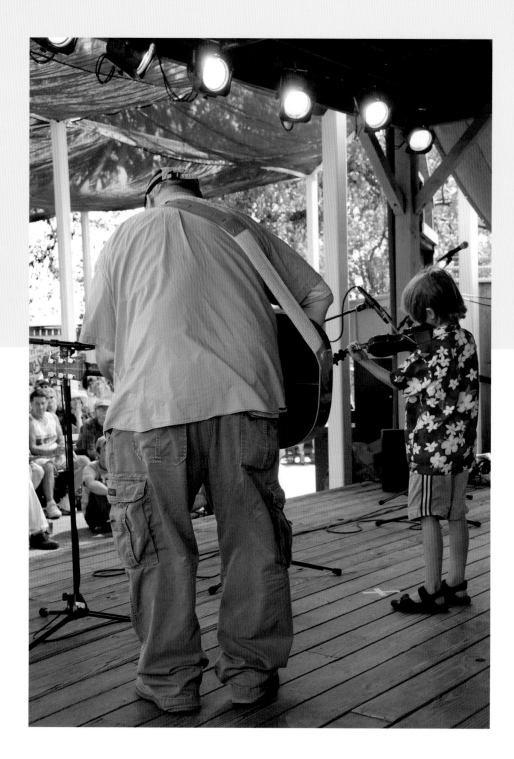

Musical Act

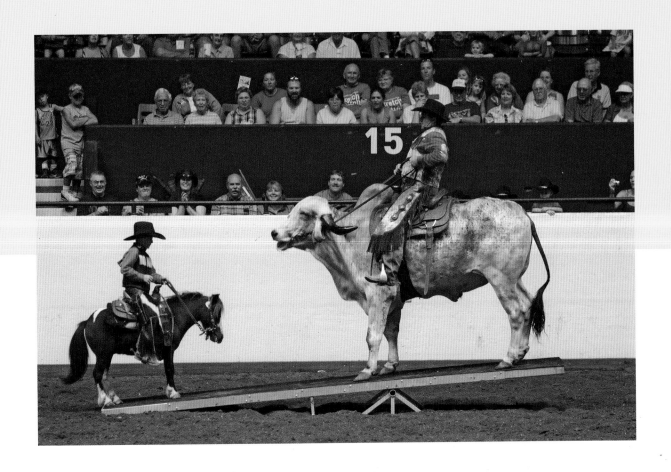

Balancing Act

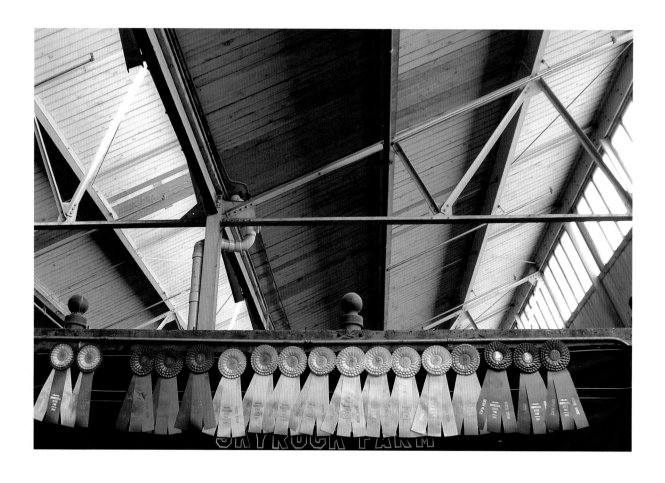

Ribbons of Many Colors

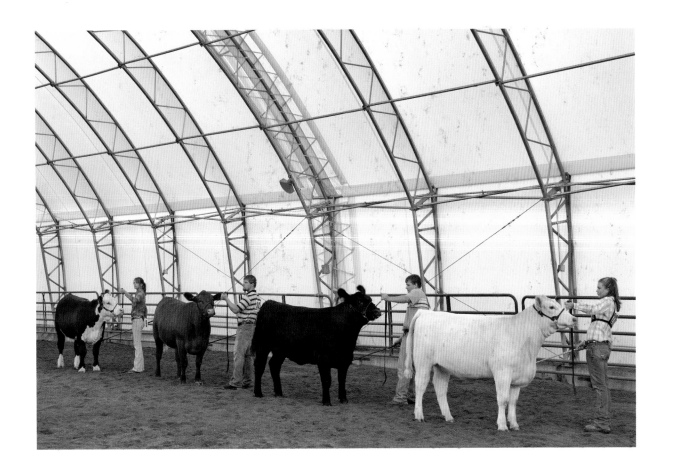

Cattle of Many Colors

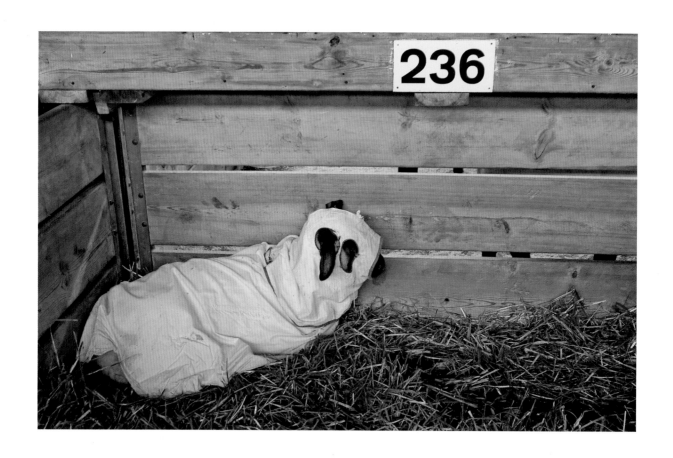

Bagged Sheep

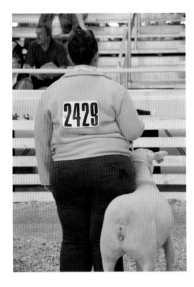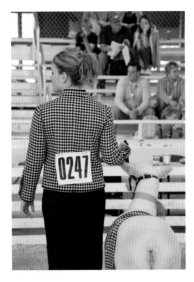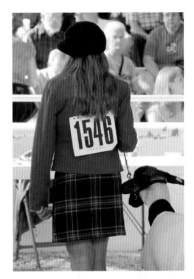

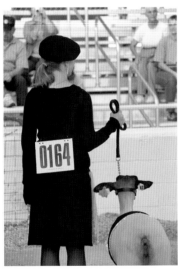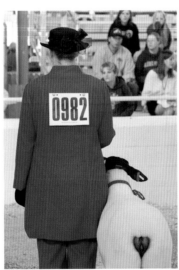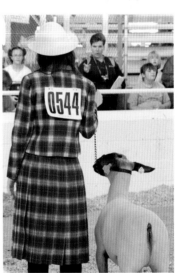

Lamb Lead

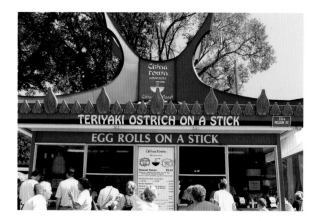

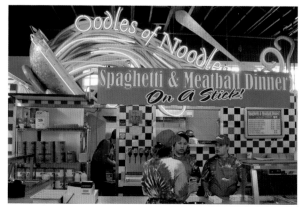

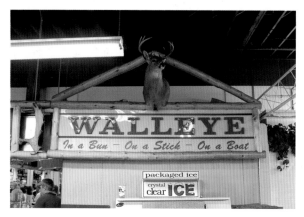

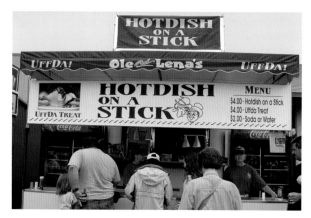

On a Stick

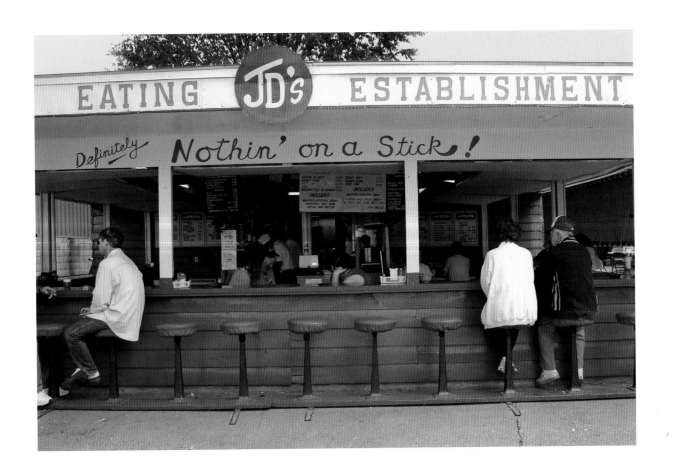

Nothin' on a Stick

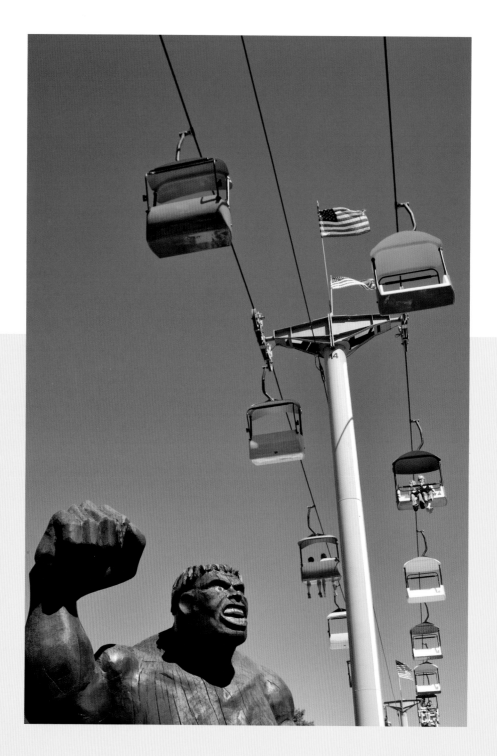

Linear

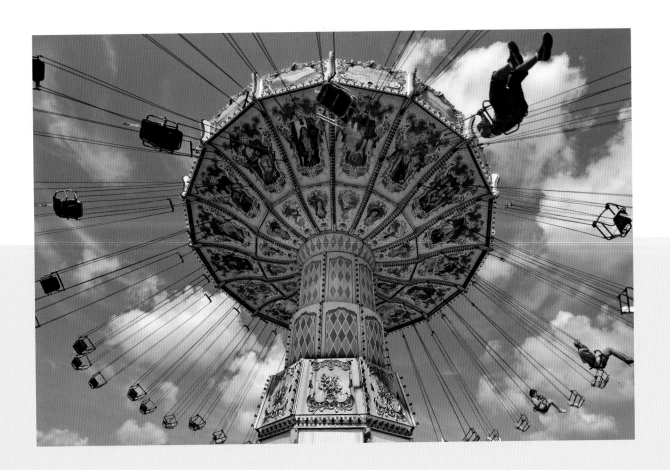

Circular

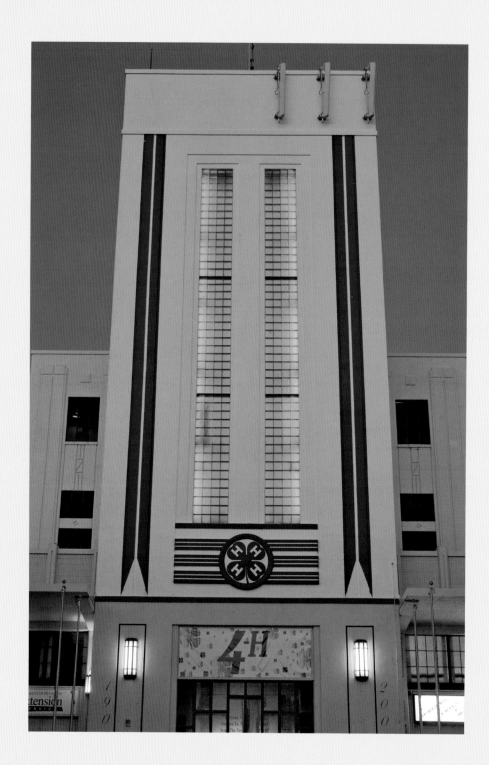

4-H at Night

Horticulture x 4

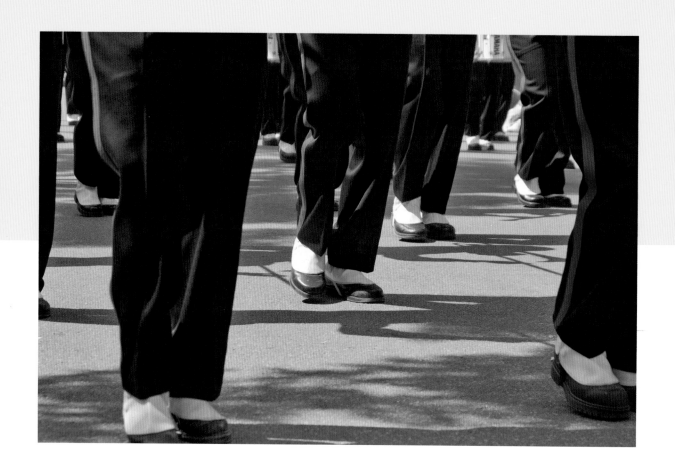

Spats

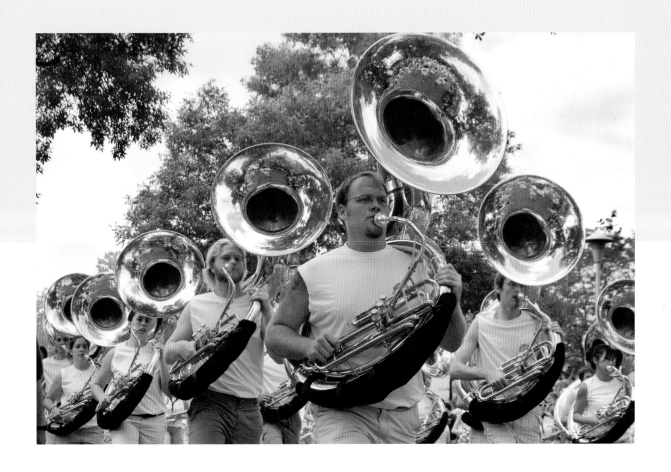

The Tuba Triangle

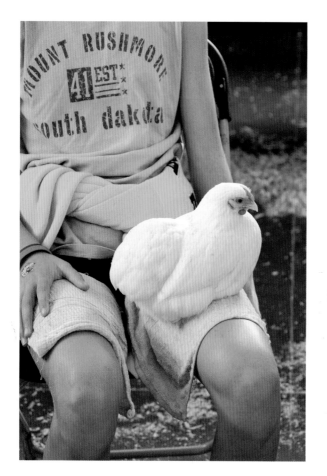

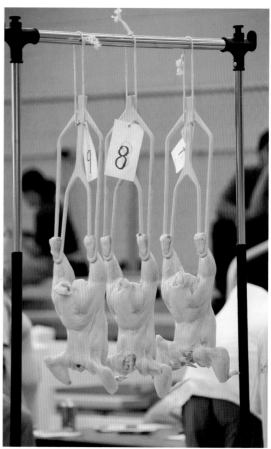

Poultry Panic

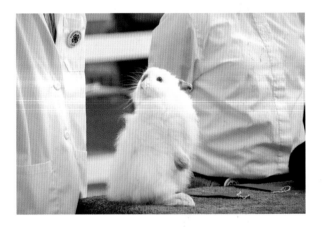 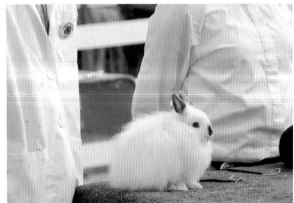

Rabbit Reassurance

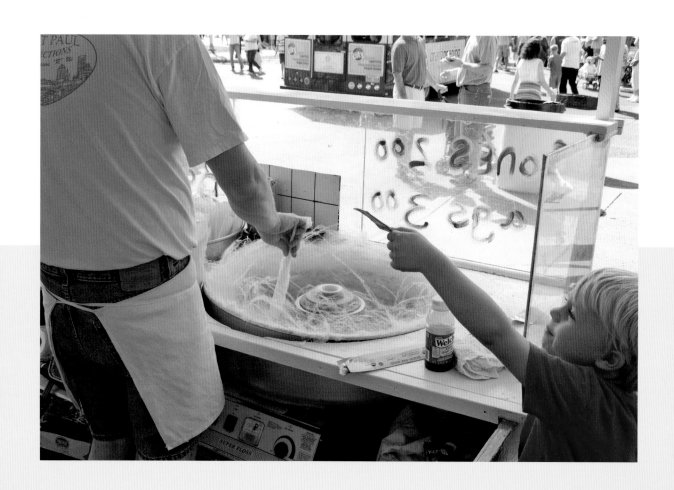

Cotton Candy Consumer

The Big Dipper

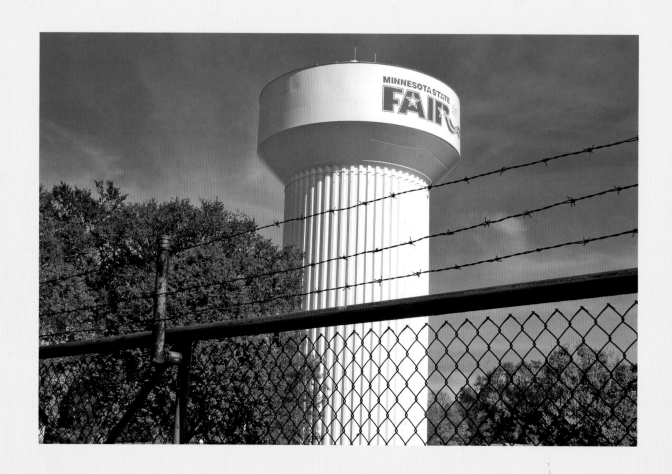

Water Tower

Fine Art

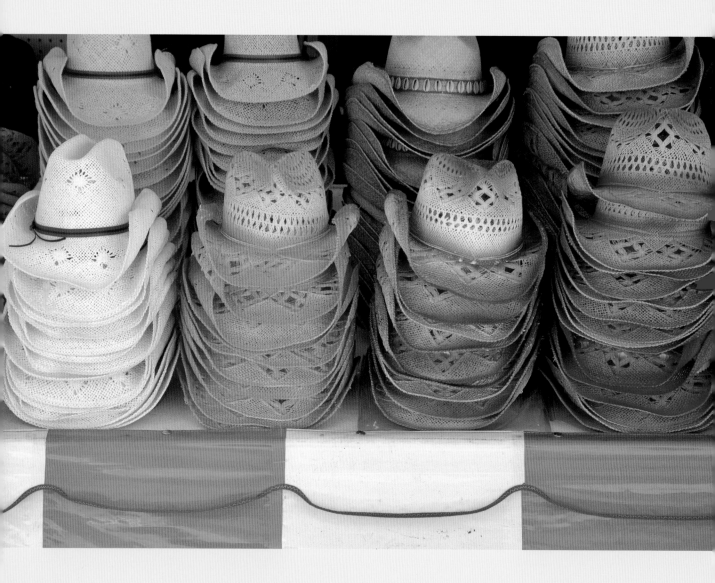

Hats of All Hues

Llama Love

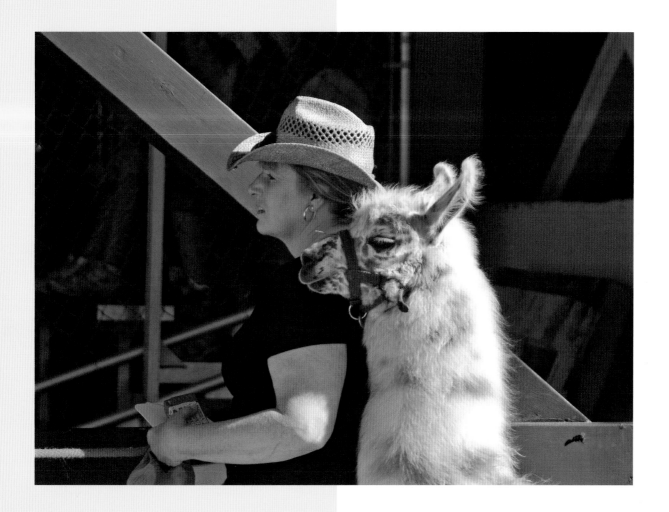

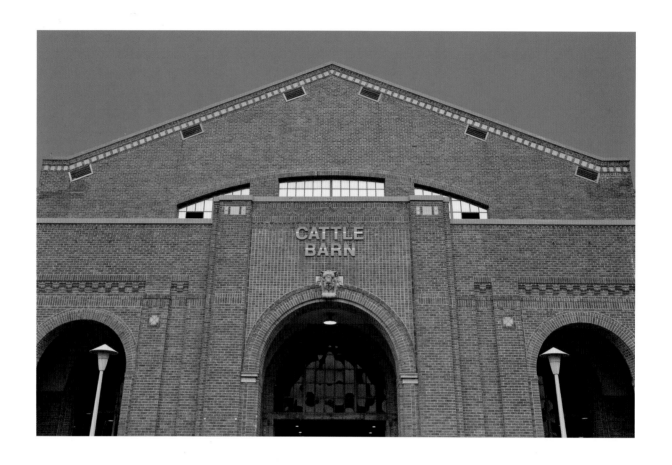

Cattle Barn

Order Here

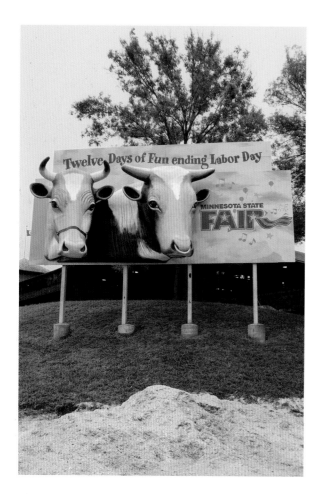

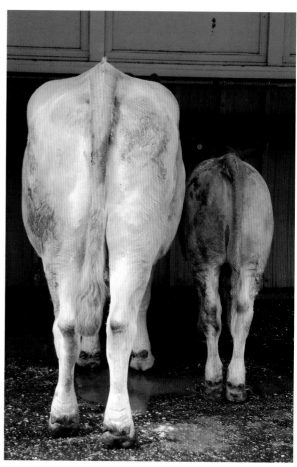

Twelve Days of Fun

Blow-up

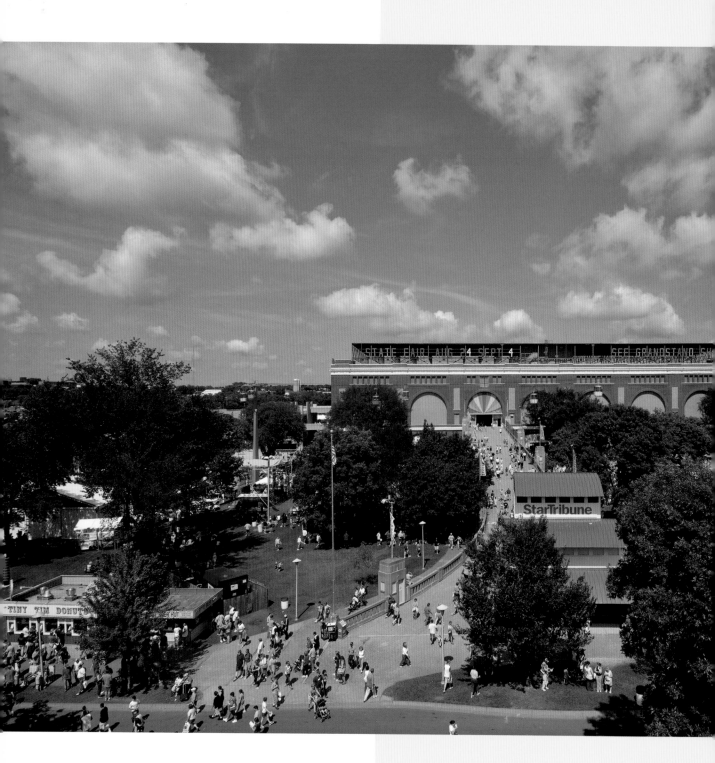

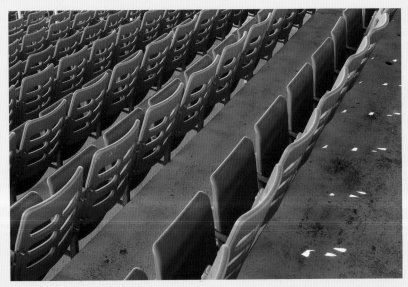

Grandstand Green I

Grandstand Green II

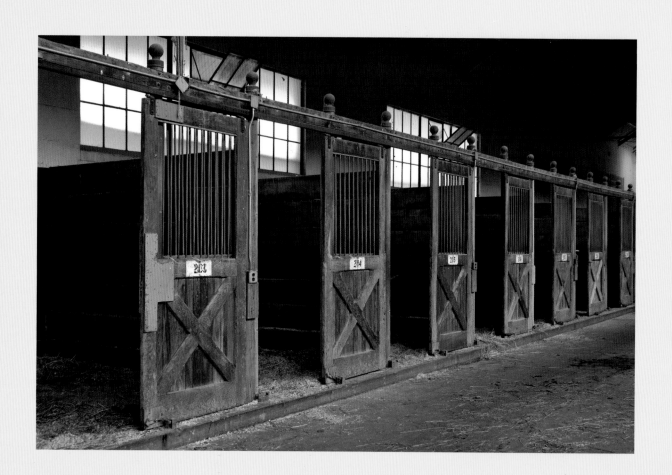

Stalls

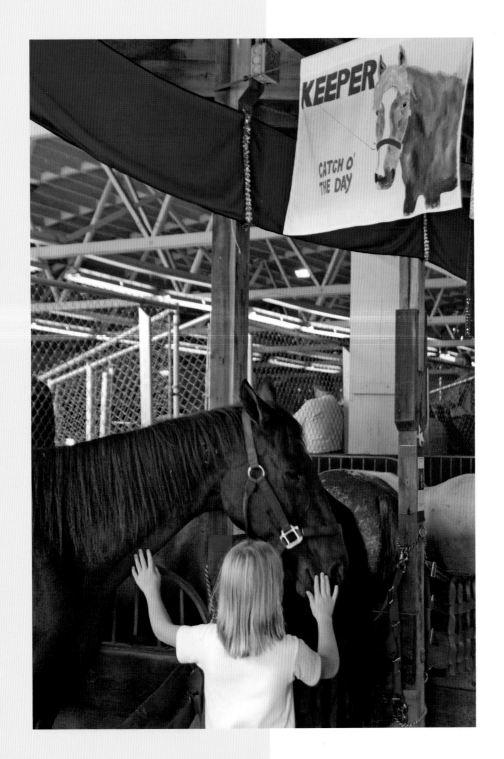

Keeper

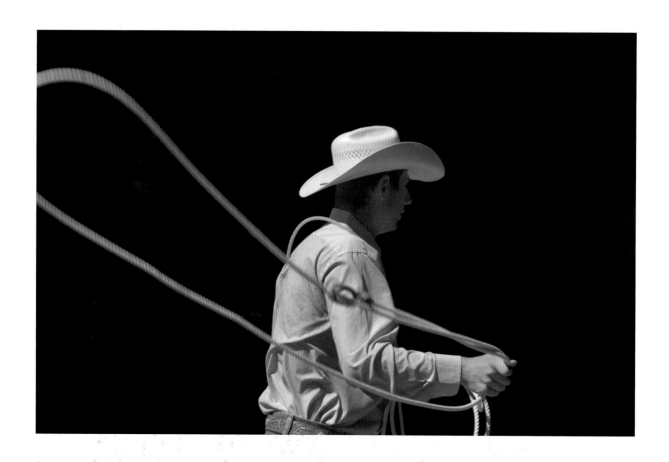

Cowboy

Cowgirl

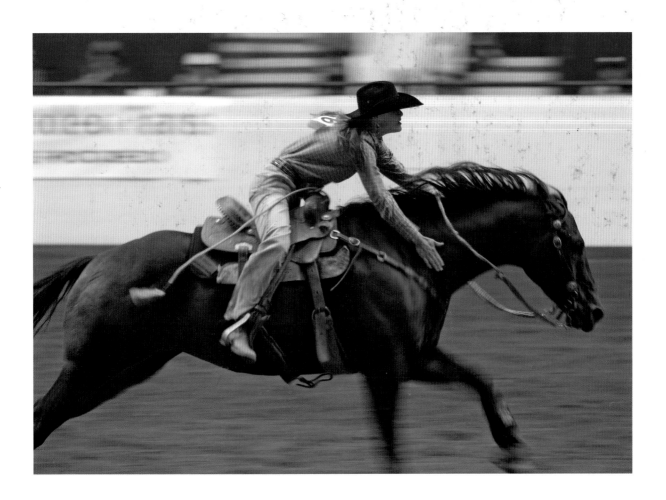

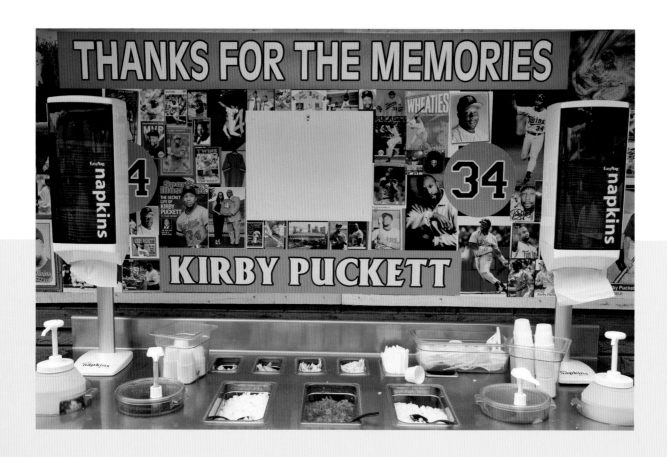

Thanks for the Seasoning

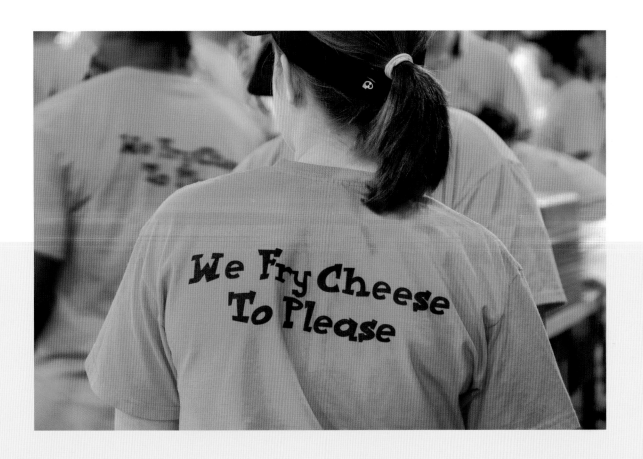

Cheese to Please

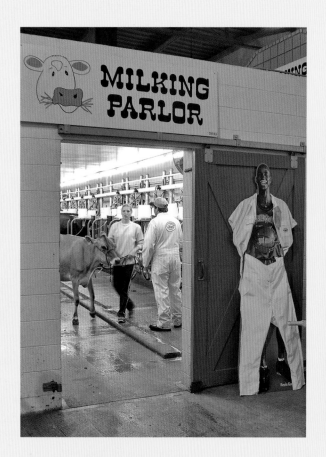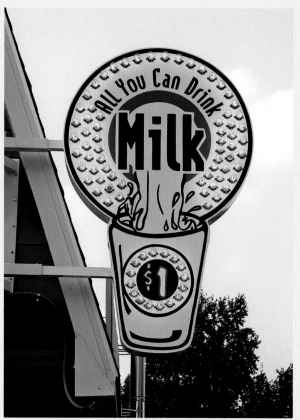

Moo Juice

Moo Juice Dispenser

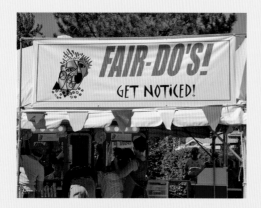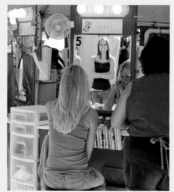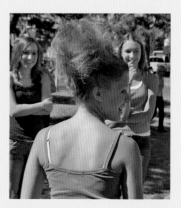

Get Noticed I

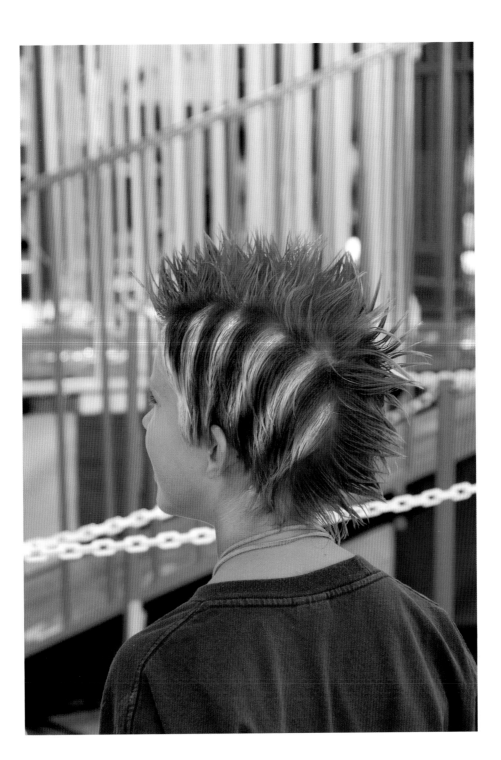

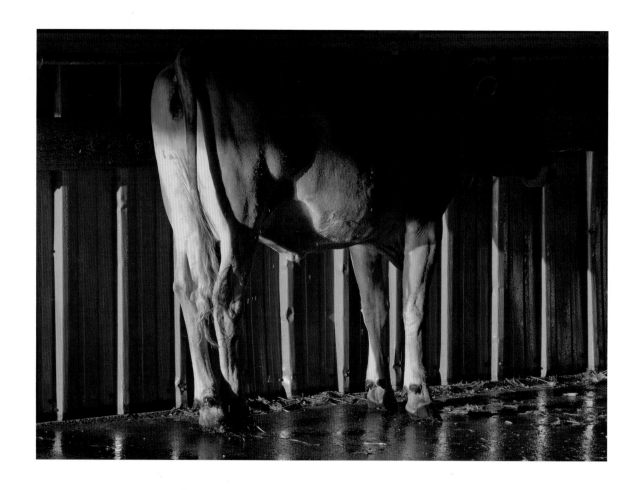

Sunrise Cow

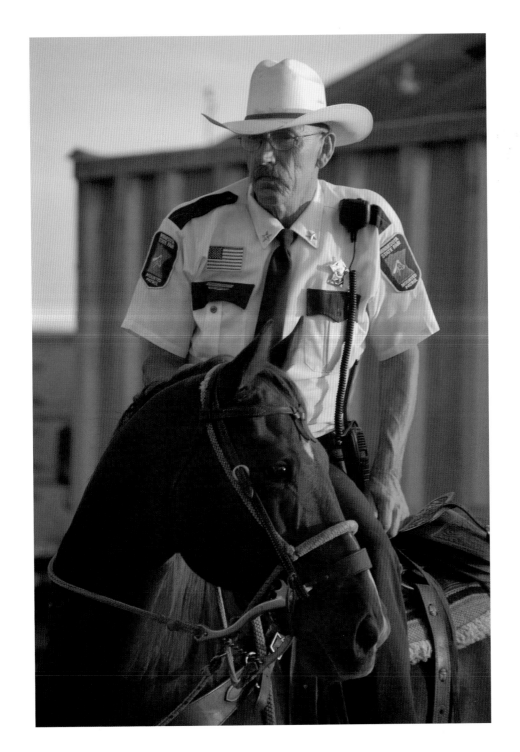

Sunset Sheriff

Sky Glider
Silhouette

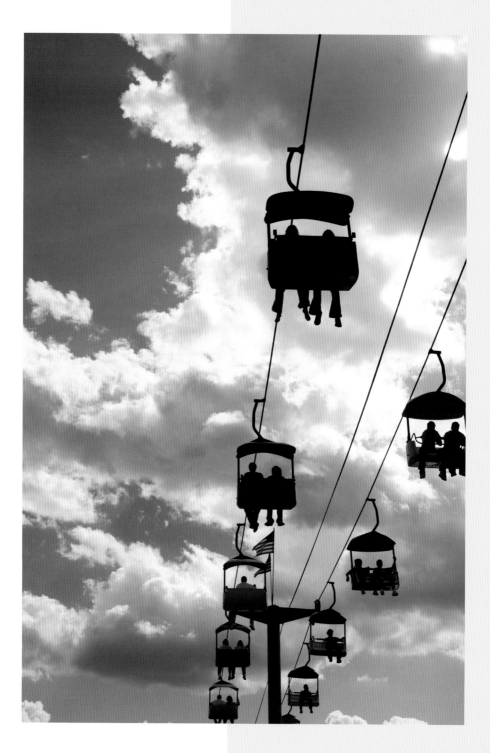

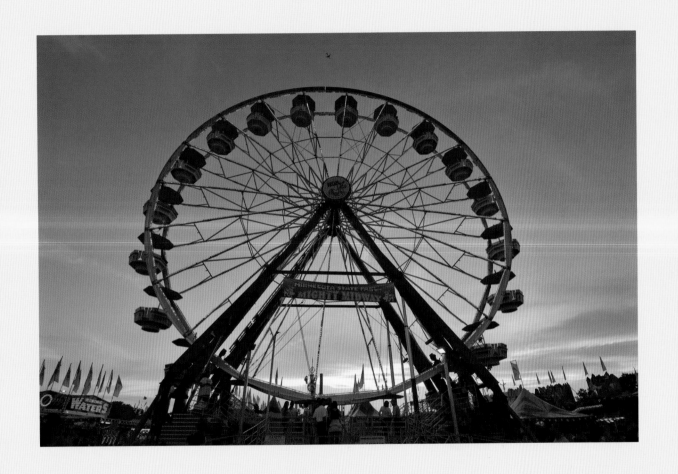

Big Wheel Silhouette

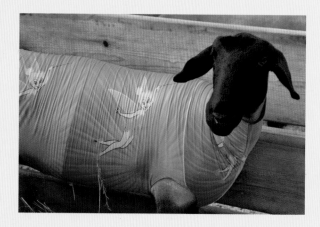 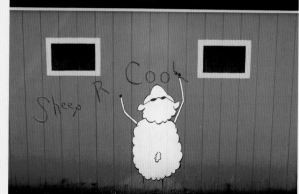

Sheep R Cool

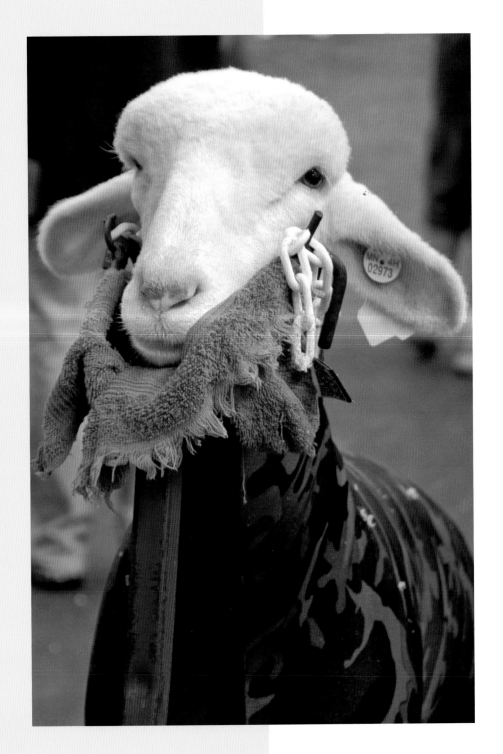

Camo Sheep

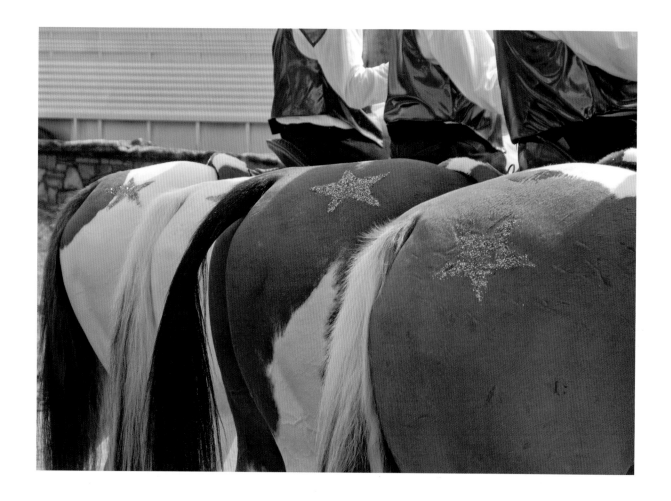

Starbutts

Precision Butts

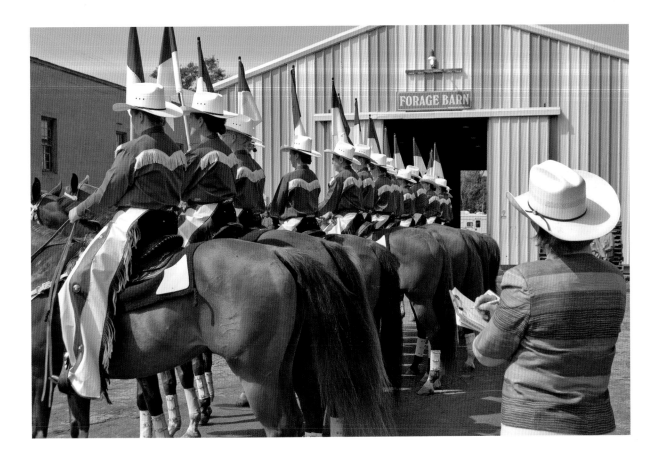

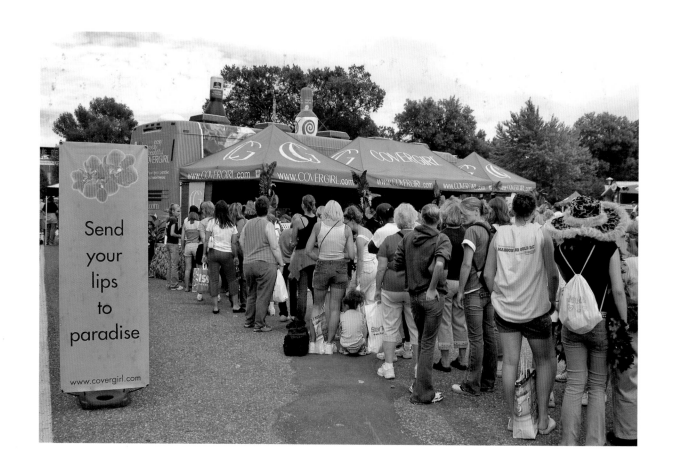

Send Your Lips to Paradise

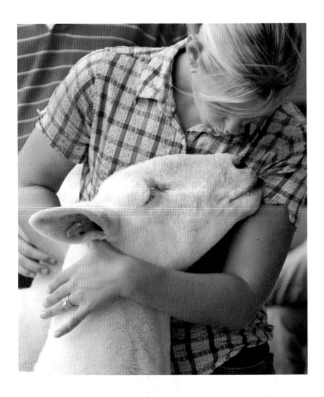

Sheep Smooch

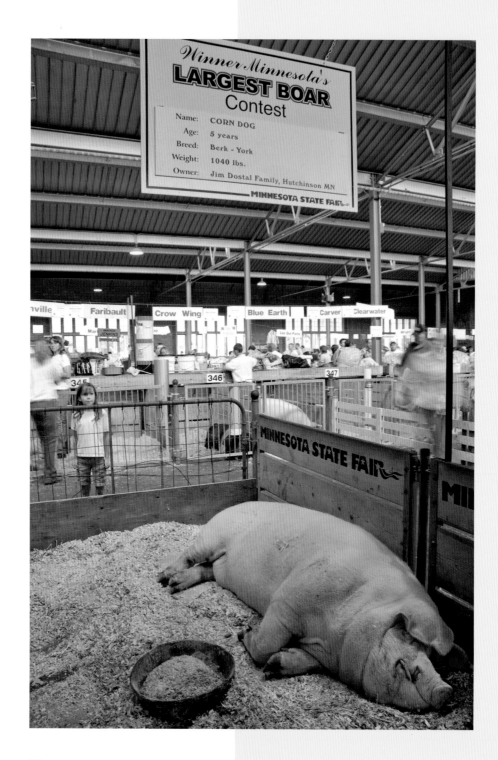

Hog Heaven

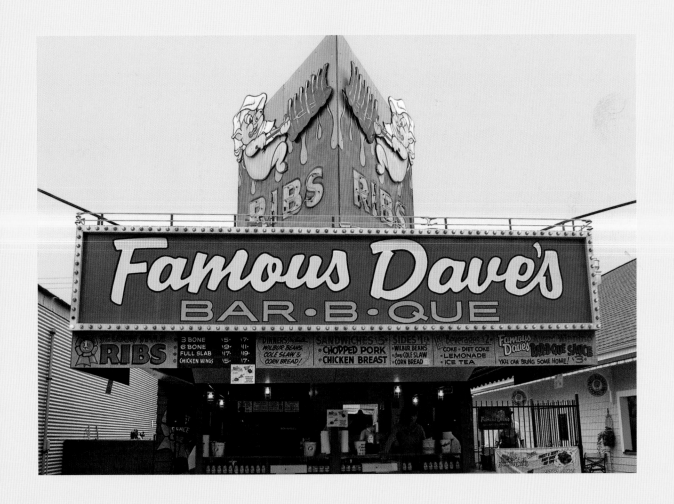

Hog Hell

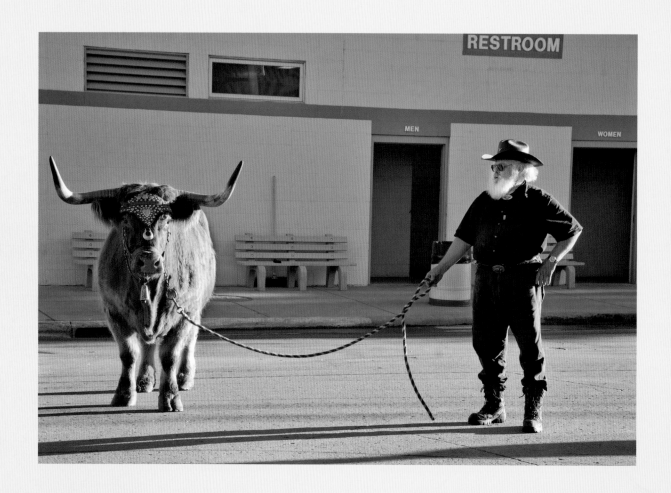

Ox Lead

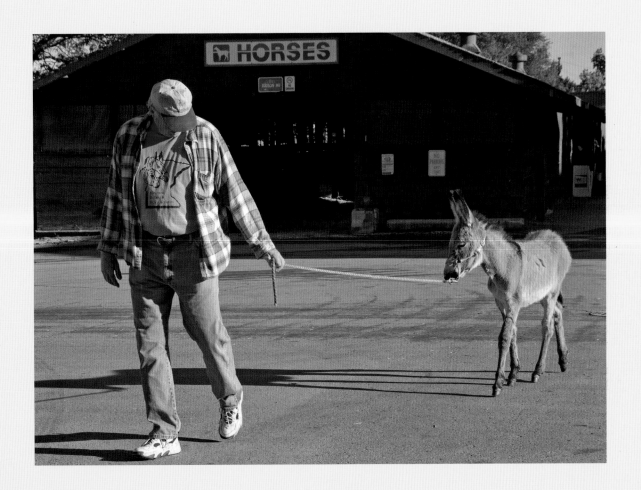

Donkey Lead

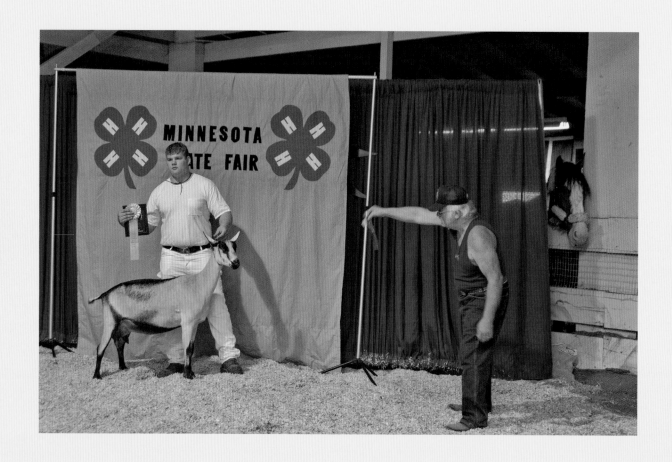

Amateur

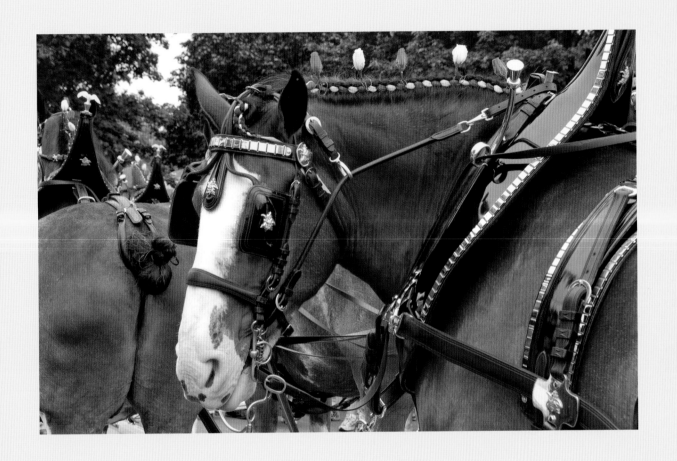

Professional

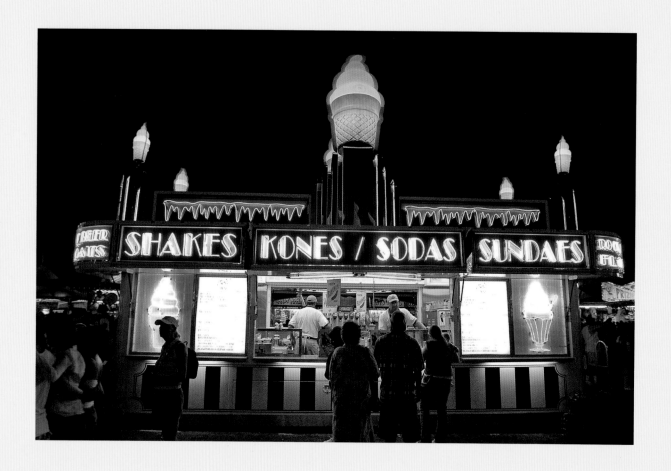

Kones

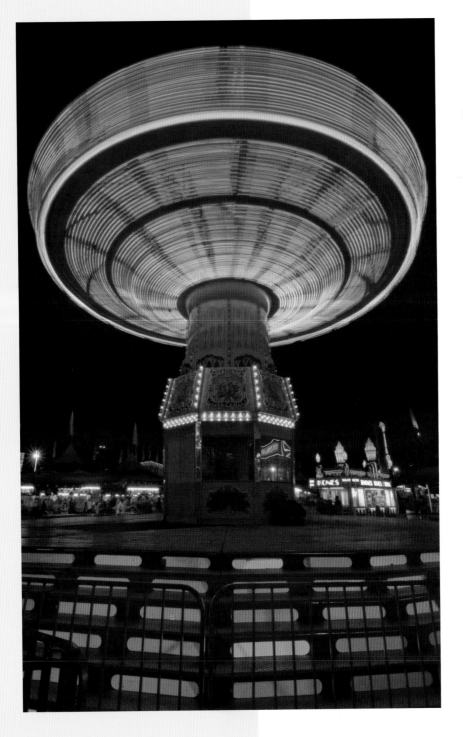

Swingin' at Night

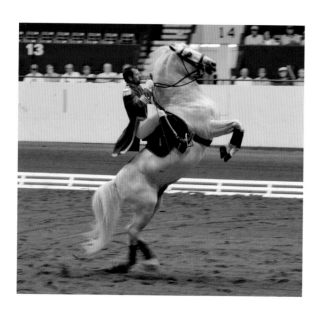
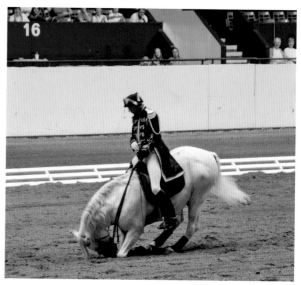

Royal Lipizzaner Stallions

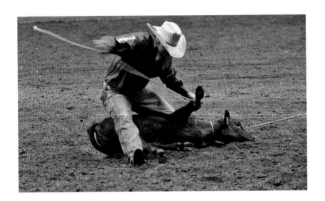

Little Dogie

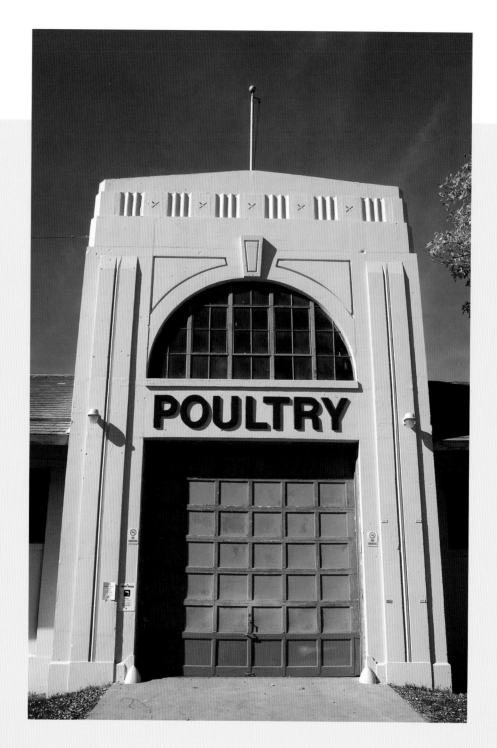

Poultry

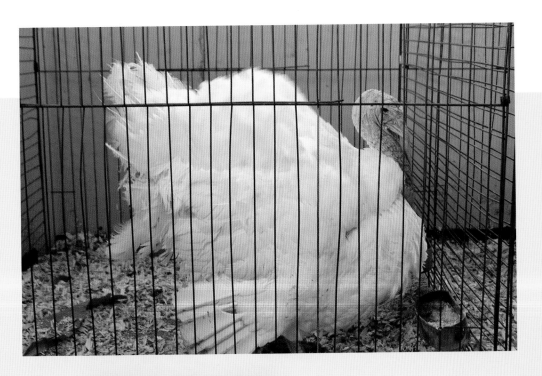

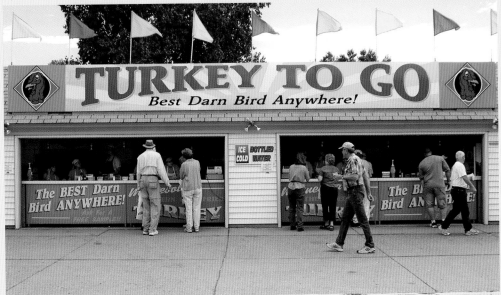

Best Darn Bird!

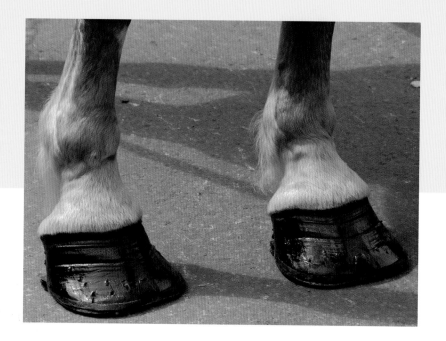
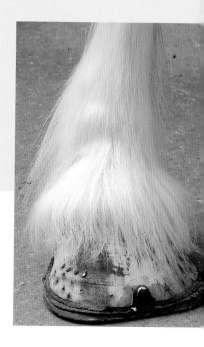

Hooves

94

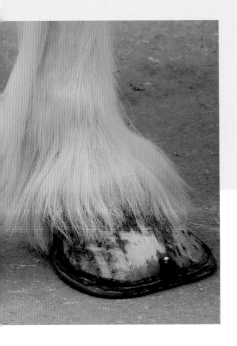
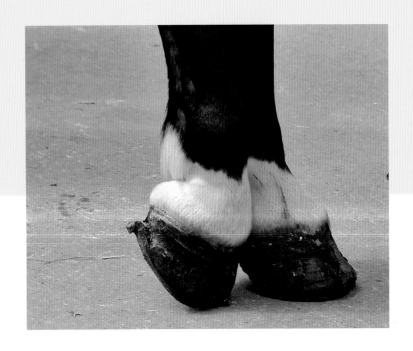

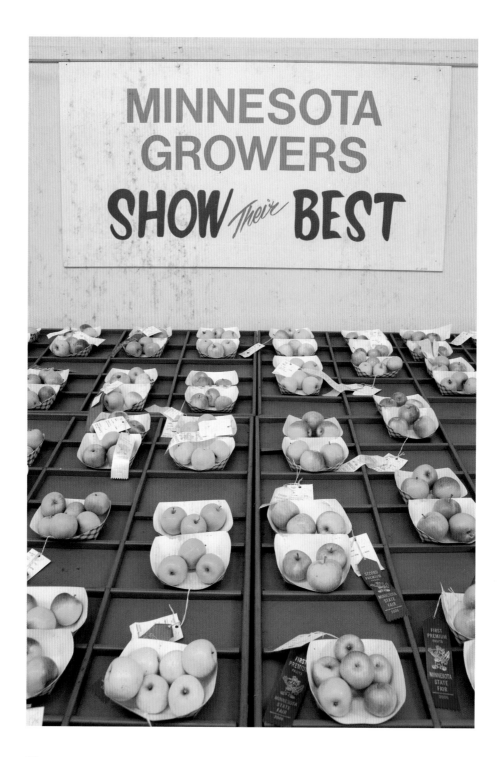

Best Apples

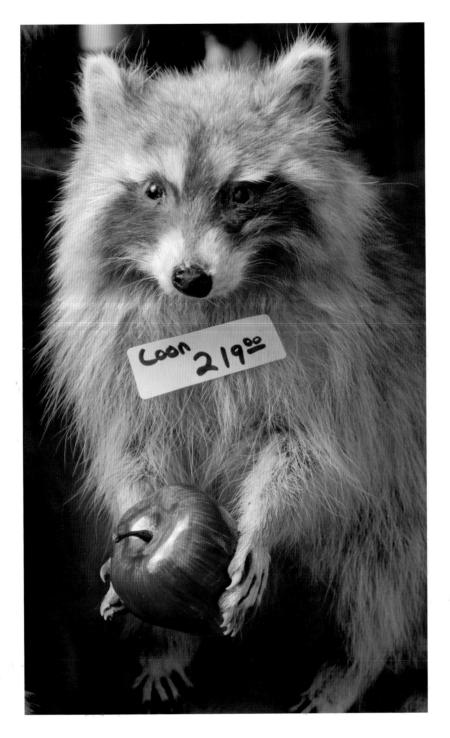

An Apple a Day . . .

Creative Containers

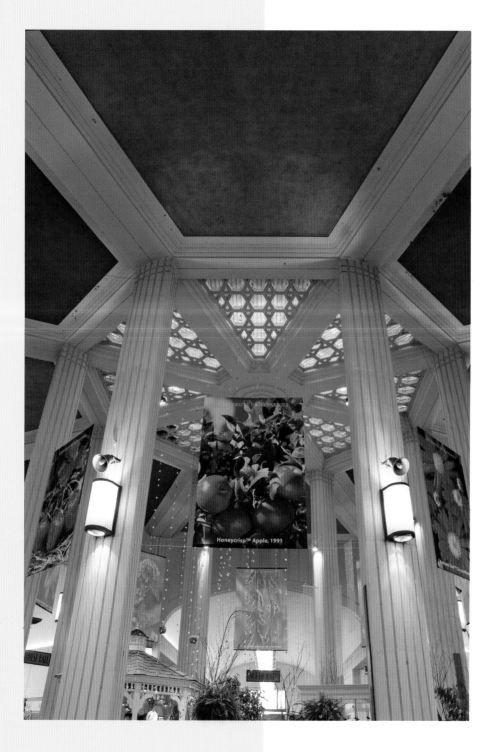

Honeycrisp™ Apple, 1991

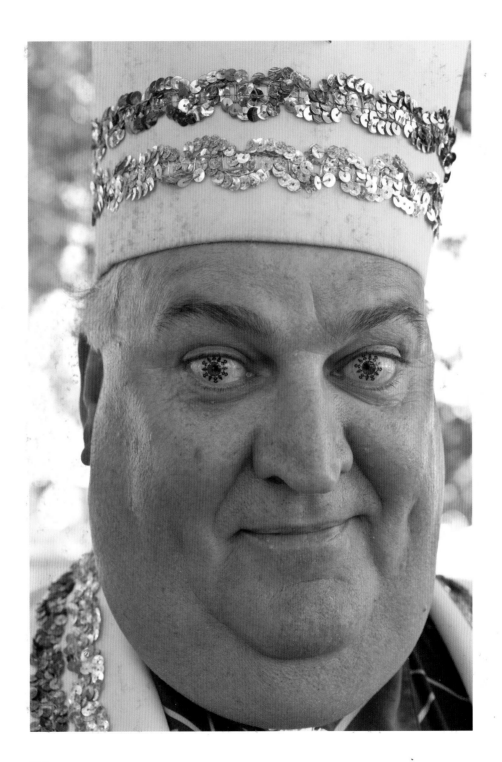

Winter Eyes

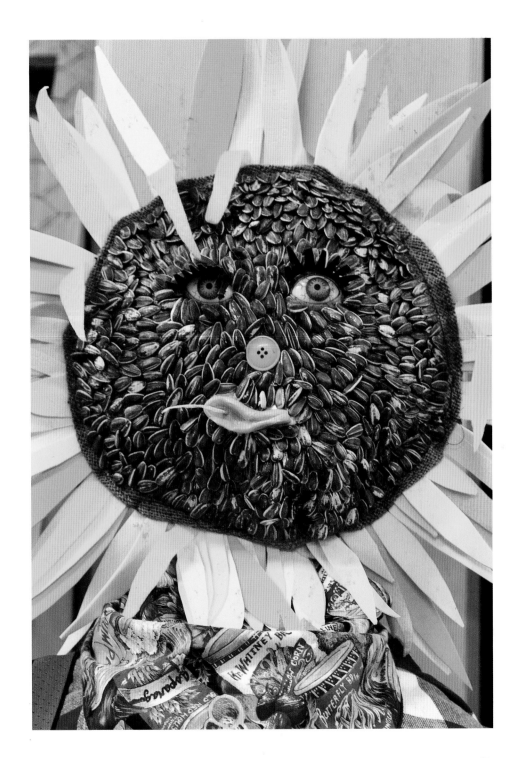

Summer Eyes

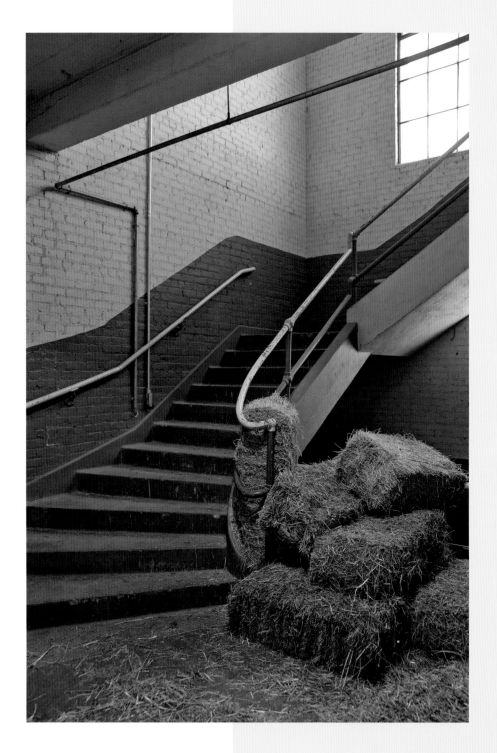

Stairway

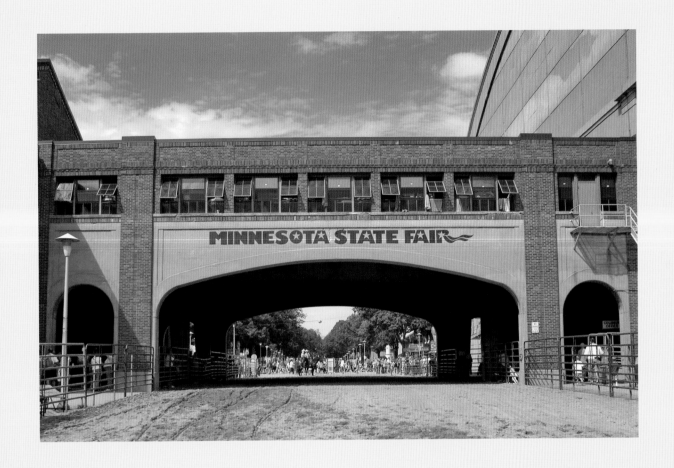

Archway

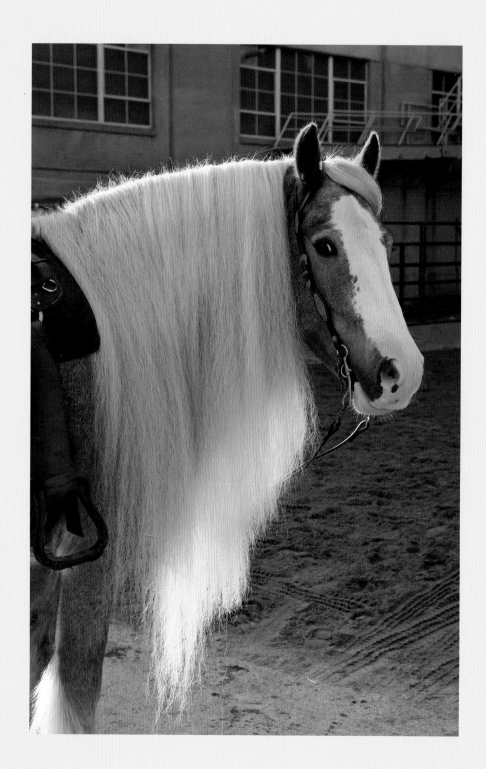

Mane I

Mane II

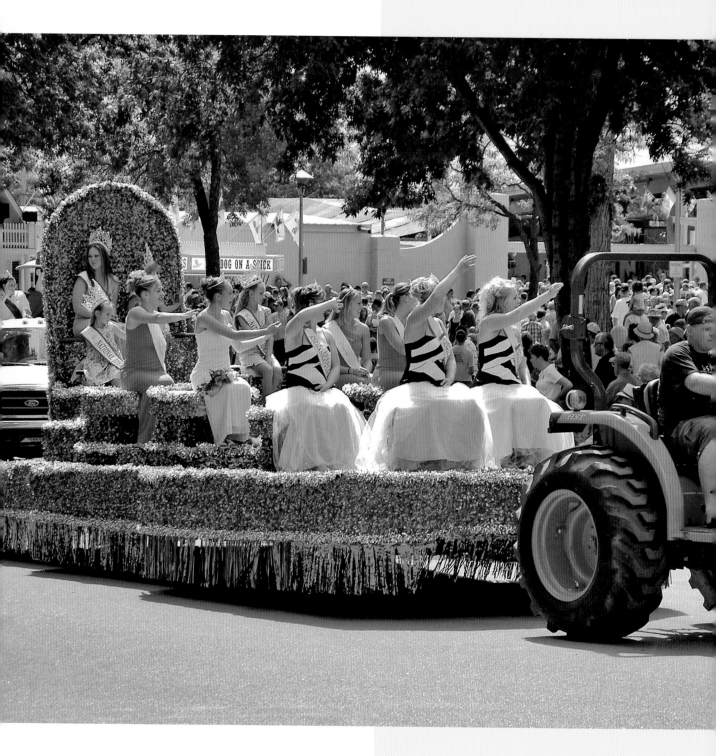

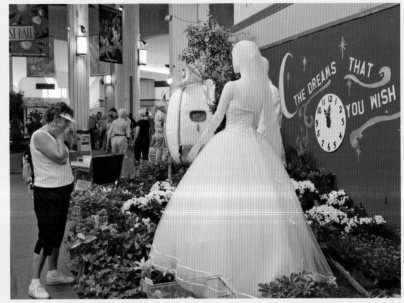

Pulling Princesses

Dreams

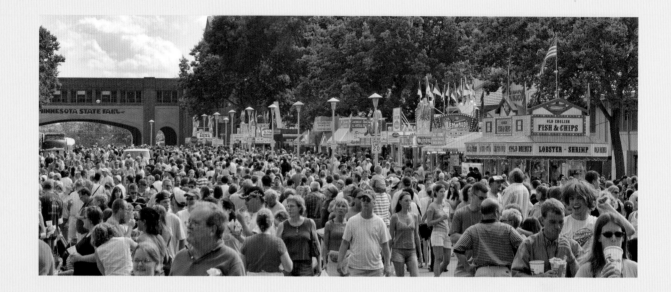

Multitude

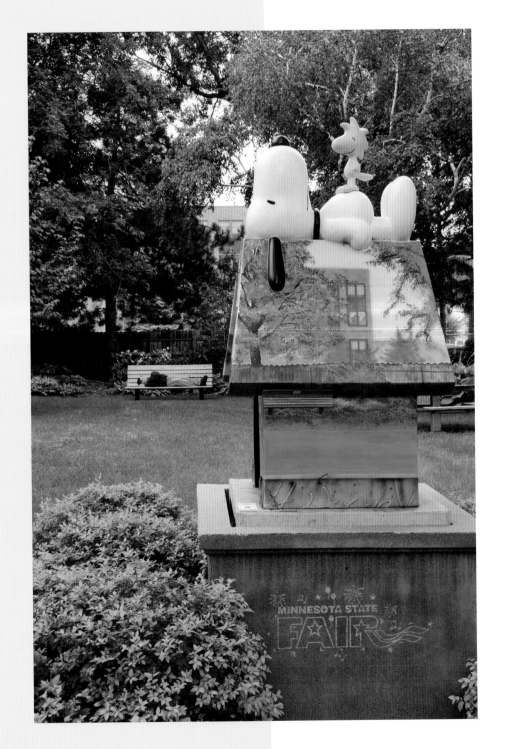

Solitude

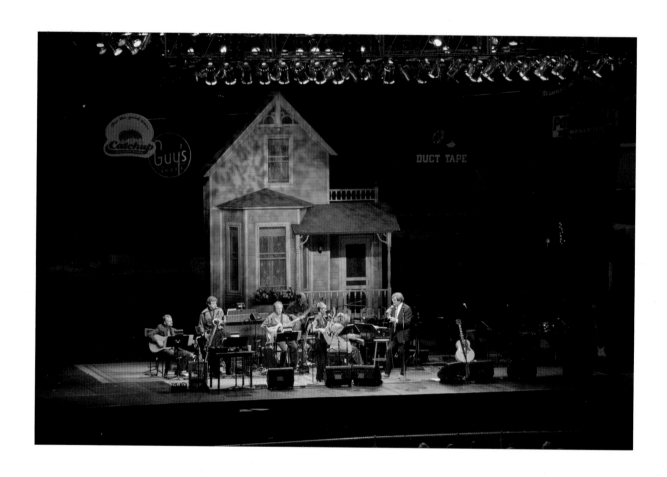

A Prairie Home Companion

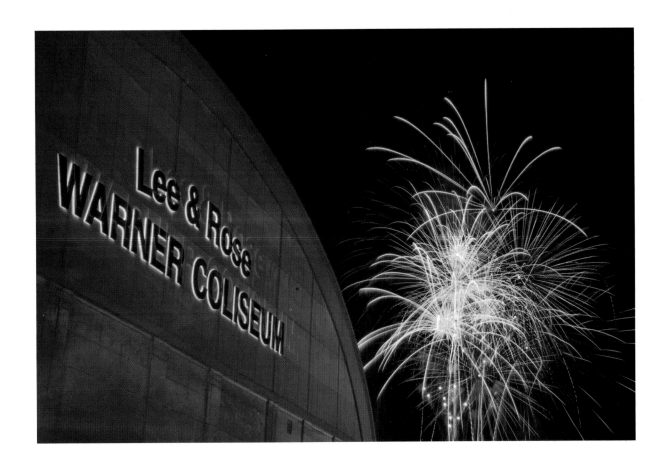

Pyrotechnics

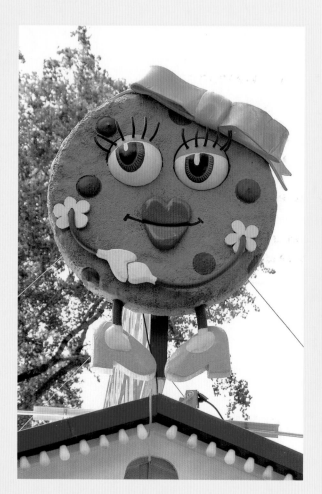

Acknowledgments

Thanks to Lorna Landvik for her laugh-out-loud introduction that truly captures the essence of my images and the character of the book.

Thanks to the Minnesota Historical Society Press, in particular Ann Regan, Shannon Pennefeather, and Greg Britton, for making this dream become a reality (and for appreciating my sense of humor!).

Thanks to photographer Kelly Povo for making me look presentable in my fair garb.

Special thanks to my family—Les, Elizabeth, and Graham—for their belief in me and for sharing my enthusiasm for the Minnesota State Fair (even if I do smell like manure for two weeks every summer!).

State Fair was designed and set in type by Steve Biel, Milwaukee, Wisconsin.
The typefaces are Fairfield and Frutiger. Printed in China by Pettit Network, Afton, Minnesota.